COUNTERPOINT *Two Centuries of American Masters*

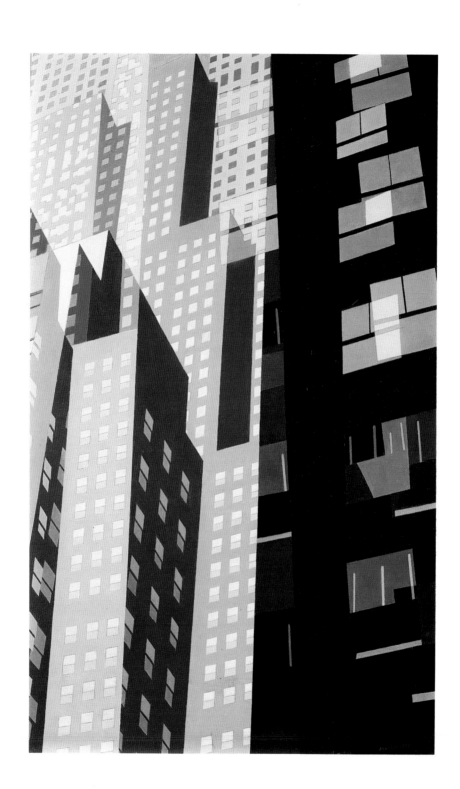

COUNTERPOINT

Two Centuries of American Masters

April 21 to June 8, 1990

Hirschl & Adler Galleries
21 East 70th Street
New York, New York 10021
212 535-8810

COVER

Fitz Hugh Lane (1805–1864)
View of Gloucester Harbor, about 1855–60 (detail)
Cat. 3

FRONTISPIECE

Charles Sheeler (1883–1965)
Windows, 1951
Cat. 28

Design: Elizabeth Finger
Editor: Sheila Schwartz
Typesetting: Michael and Winifred Bixler
Printing: Meridian Printing

All photographs are by Helga Photo Studio,
with the exception of cats. 8, 30, 37, 38,
44, and 61 by Zindman/Fremont.

CONTENTS

NOTES TO THE CATALOGUE

Many of the works included in this cata-
logue have extensive bibliographies and
exhibition histories. Due to space consider-
ations, lengthy references have been signifi-
cantly abridged here. Further information
on many of the works is available upon
request.

Dimensions are in inches; height precedes
width precedes depth.

FOREWORD

When Hirschl & Adler last organized a survey exhibition of the finest works from its collections, the year was 1984, and the show, *The Art of Collecting*, focused on the gallery's best eighteenth-, nineteenth-, and twentieth-century American painting and sculpture. In the ensuing half dozen years, the collections of Hirschl & Adler Galleries have expanded greatly. American paintings and sculpture of the last century now share space with American decorative arts of that period; major works of American modernism are seen with furniture and objects of the Arts & Crafts Movement; and well-known master prints of both centuries are displayed alongside exceptional works by lesser-known printmakers. It was in part to celebrate this expanded presence that the gallery recently published *The State of the Arts—1990*, a book that highlights all of its areas of specialization, including nineteenth- and twentieth-century European art, as well as the collections of Hirschl & Adler Folk and Hirschl & Adler Modern.

Counterpoint features a selection from the holdings of our various departments of American art. One of the delights of organizing a survey exhibition of this kind is the prospect of exhibiting and publishing works of art of considerable quality that have not made a public appearance in a very long time. An extraordinary pair of portraits by Ralph Earl (cat. 2), for example, has been confined to the parlors of a succession of descendants of the subjects for exactly two hundred years, and are exhibited here seemingly for the first time since their completion in February 1790. A major painting by Albert Bierstadt (cat. 5) was previously known only through an unillustrated exhibition review in 1863. Through the present exhibition and publication, it can now be integrated once again into the oeuvre of this important American landscape painter. Thomas Eakins' portrait of John Gest (cat. 15), although widely discussed in the literature as one of his most potent works, has not actually been seen publicly since the Eakins memorial exhibition at the Pennsylvania Academy of the Fine Arts in 1917. And Louis Lozowick's *Seattle* (cat. 27) is a rediscovery of a work that was painted in Berlin and was previously known only through a later replica painted in the United States. Whereas one can find references—even if obscure—to the works by Earl, Bierstadt, and Lozowick, Martin Johnson Heade's *Two Hummingbirds by an Orchid* (cat. 8) appears to be a totally new find and can now take its rightful place among the earliest and best examples of Heade's depictions of this subject.

In the decorative arts, an apparently unique Philadelphia Chippendale chair (cat. 59) is published here for the first time, as is an extraordinary matching sideboard and cellarette (cat. 62), made in Boston or Salem, Massachusetts, in 1829, that will surely earn its place as an important monument of the Classical Revival in America. And the "Eliptic Bureau" by Joseph Barry & Son (cat. 58) brings to light another fine example of a form that is synonymous with the best furniture made in Philadelphia in the early years of the Greek Revival period.

It is only through the considerable effort of all members of our staff that the collection of Hirschl & Adler Galleries remains the bearer of such riches, as works are continually gathered, documented, conserved, and placed in collections, public and private, throughout the world. Ann Yaffe Phillips and Meredith E. Ward coordinated the publication of this catalogue and the accompanying exhibition, with contributions by Douglas Dreishpoon, Sandra K. Feldman, Janet A. Flint, Joseph Goddu, Bruce Lazarus, Susan E. Menconi, M.P. Naud, Arleen Pancza-Graham, and James L. Reinish.

STUART P. FELD

EIGHTEENTH & NINETEENTH-CENTURY PAINTINGS

John Singleton Copley

1738–1815

1.

Portrait of Joseph Scott, about 1765
Oil on canvas, 49¾ x 39

RECORDED: Augustus Thorndike Perkins, *A Sketch of the Life and a List of Some of the Works of John Singleton Copley* (1873), p. 105 // Frank W. Bayley, *A Sketch of the Life and a List of Some of the Works by John Singleton Copley* (1910), p. 99 // Frank W. Bayley, *Life and Works of John Singleton Copley, Founded on the Work of Augustus Thorndike Perkins* (1915), p. 222 // Barbara Neville Parker and Anne Bolling Wheeler, *John Singleton Copley: American Portraits* (1938), pp. 180–81, pl. 54 // Jules David Prown, *John Singleton Copley in America, 1738–1774* (1966) I, pp. 53, 228 fig. 172

EXHIBITED: Boston Athenaeum, 1864, *Annual Exhibition* (third edition), no. 330 // Boston Athenaeum, 1871, *Annual Exhibition* (first edition), no. 231 (fourth edition), no. 201 // Whitney Museum of American Art, New York, 1972, *18th- and 19th-Century American Art from Private Collections*, no. 18, as dated 1760 // Hirschl & Adler Galleries, New York, 1975–76, *American Portraits by John Singleton Copley*, no. 17 illus.

EX COLL.: the Misses Winslow, Boston, 1873; George Scott Winslow, Jr., great-great-grandson of the sitter, 1910; to his daughter, Mrs. Leonard Jacob, Greenwich, Connecticut, 1938; Mrs. Theodore S. Watson, Greenwich, Connecticut, 1966; to her estate; to [Hirschl & Adler Galleries, New York, 1975–77]; to private collection, until 1990

This portrait of Joseph Scott was painted during the brief period between Copley's maturation as an artist in the early 1760s and his departure for England in 1774. As capable of painting damasks and the glittering surfaces of wood and silver as he was of capturing a compelling likeness, Copley produced an unforgettable group of portraits that were certainly better works of art than any he himself had yet seen.

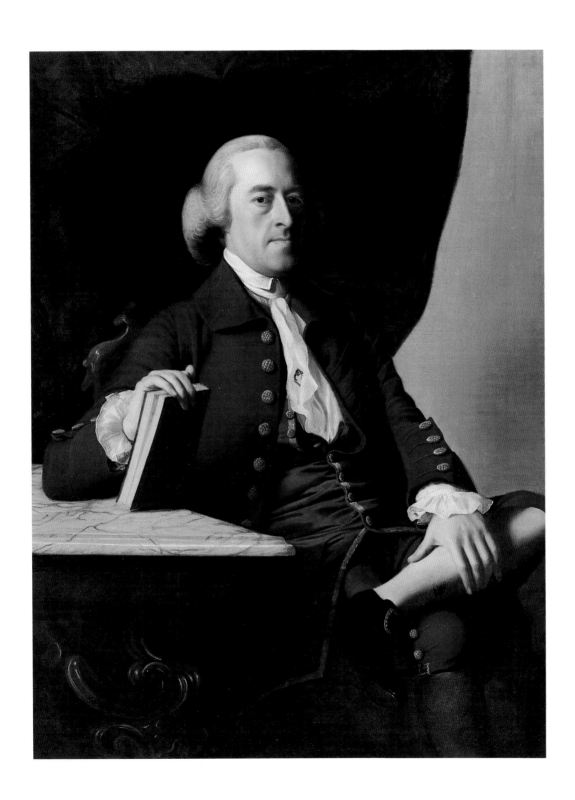

Ralph Earl

1751–1801

2.

Portrait of Thomas Tucker and *Portrait of Sarah Tucker*, 1790
Oil on canvas, each 37¾ x 31¾
Thomas Tucker: signed and dated (on edge of table): R. Earl Pixt Feb.9.1790; *Sarah Tucker*: signed and dated (at lower left): R. Earl/Pinxt/1790
Collection of Hirschl & Adler Folk

RECORDED: Elizabeth Mankin Kornhauser, "Ralph Earl: Artist-Entrepreneur" (Ph.D. dissertation, Boston University, 1988), I, pp. 137, 332

EX COLL.: by descent in the family, until 1989

In February 1790, when these portraits were painted, Earl was just beginning what would be a remarkably productive year executing portraits in western Connecticut. Thomas Tucker (1748–1820) was a retired merchant and resident of Danbury. Earl probably met Mr. and Mrs. Tucker through Dr. Mason Fitch Cogswell, a Hartford physician and patron of the artist, whose connections throughout Connecticut provided Earl with numerous portrait commissions (Kornhauser, *op. cit.*, p. 332).

These portraits have survived in a remarkable state of preservation, having only recently been cleaned for the first time in two hundred years. They have never been lined and retain their original frames. In quality, they rank among the artist's finest works.

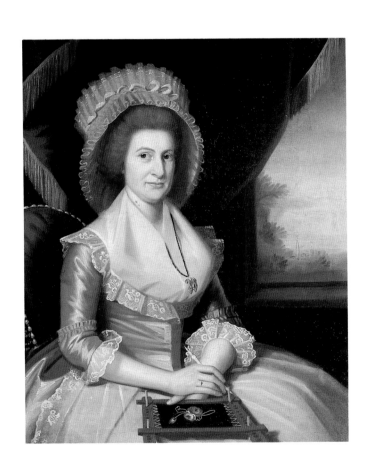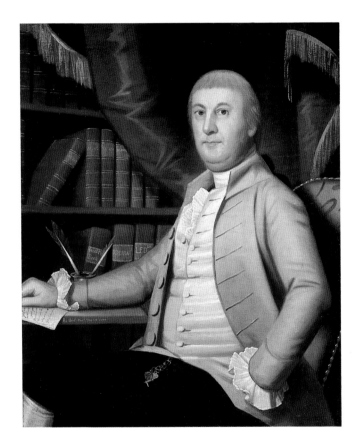

Fitz Hugh Lane

1805–1864

3.

View of Gloucester Harbor, about 1855–60
Oil on canvas, 24⅛ x 36¼

RECORDED: letter, John Wilmerding,
National Gallery of Art, Washington, D.C.,
to former owner (Jan. 27, 1988) // John
Wilmerding, *Paintings by Fitz Hugh Lane*
(National Gallery of Art, Washington,
D.C., 1988), p. 32 fig. 7 in color, cf. pp. 41
no. 13 illus., 50 no. 25 illus., 51 no. 24
illus., 59, 75 no. 12 illus.

EX COLL.: private collection, Chicago, by the
1930s, until 1969; by descent in the family,
1969–88

By the mid-1850s Lane's style had evolved
from an almost folk-art linearity into the
expansive, light-filled compositions char-
acteristic of fully developed Luminism. A
poetry of silence pervades the best of these
works, a mood that *View of Gloucester
Harbor* shares with Lane's two very similar
views of Boston, both titled *Boston Harbor
at Sunset* (collections of Jo Ann and Julian
Ganz, Jr., Los Angeles [Wilmerding, *op.
cit.*, p. 50 illus.], and Museum of Fine Arts,
Boston [ibid., p. 51 illus.]).

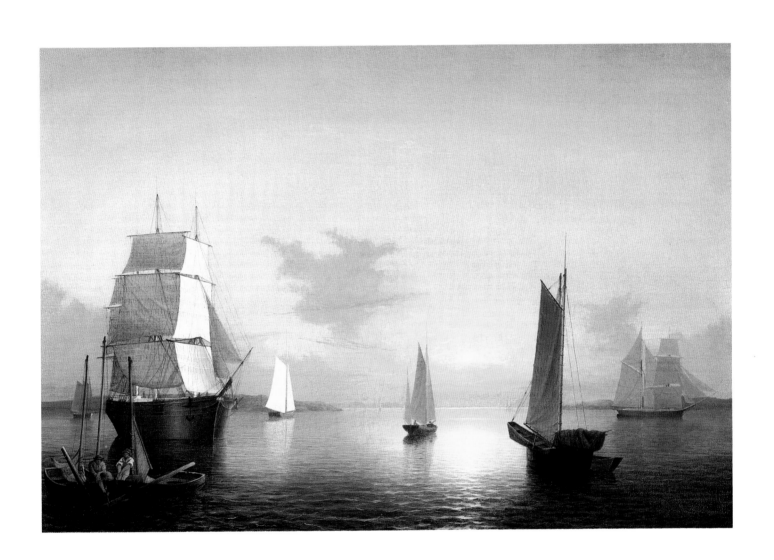

Frederic Edwin Church

1826–1900

4.

The Cordilleras: Sunrise, 1854
Oil on canvas, 28½ x 43
Signed and dated (on the rock, at lower
center): F.E. CHURCH/1854

RECORDED: Frederic E. Church, diary
(quoted by David C. Huntington,
"Landscapes and Diaries: The South
American Trips of F.E. Church,"
Brooklyn Museum Annual, V [1963–64],
pp. 84–85, Aug. 25 and 30, 1853 // letter,
Church to E.P. Mitchell, Dec. 14, 1854,
Gratz Collection, Historical Society
of Pennsylvania, Philadelphia (Archives
of American Art, roll P22 frames 103–04)
// David C. Huntington, *The Landscapes
of Frederic Edwin Church: Vision of an
American Era* (1966), p. 43, collection of
Mrs. Dudley Parker, Morristown, New
Jersey // Franklin Kelly and Gerald L. Carr,
*The Early Landscapes of Frederic Edwin Church,
1845–1854* (1987), p. 119 // Franklin Kelly,
*Frederic Edwin Church and the National Land-
scape* (1988), pp. 77, 78 pl. 51, 174 no. 51

EXHIBITED: National Academy of Design,
New York, 1855, *Thirtieth Annual Exhibi-
tion*, no. 49, lent by Jonathan Sturges //
National Gallery of Art, Washington,
D.C.; Amon Carter Museum, Fort Worth;
and Los Angeles County Museum of
Art, 1981–82, *An American Perspective:*
*Nineteenth-Century Art from the Collection of
Jo Ann & Julian Ganz, Jr.*, pp. 33–34,
36 fig. 25 in color, 38 notes 43–46, 38 detail
illus., 39, 121 illus., 122 // National Gallery
of Art, Washington, D.C., 1989–90,
Frederic Edwin Church, pp. 48, 49, 72 notes
73–74, 80 no. 20 illus. in color, 161–62,
201 no. 20

EX COLL.: Jonathan Sturges, Esq., New
York, 1855–67; Mrs. Dudley Parker, Mor-
ristown, New Jersey, by 1966; to [Robert
Weimann, Ansonia, Connecticut, by 1967];
to private collection, 1967–77; to [Hirschl
& Adler Galleries, New York, 1977]; to
Mr. & Mrs. Julian Ganz, Los Angeles,
1977–89

In 1854 Church described *The Cordilleras:
Sunrise* as "unquestionably the finest pic-
ture I have painted" (letter, Church to
Mitchell, *loc. cit.*). Worked up from pencil
drawings and oil sketches he had executed
during his first trip to South America in
1853, this painting is seminal in his artistic
development. It is the first, and the most
successful, of four South American views
Church painted in 1854 and exhibited in
1855. The other three are *Tequendama Falls,
near Bogota, New Granada* (Cincinnati Art
Museum), *Scene on the Magdalena* (National
Academy of Design, New York), and
Tamaca Palms (National Museum of Amer-
ican Art, Smithsonian Institution, Wash-
ington, D.C.).

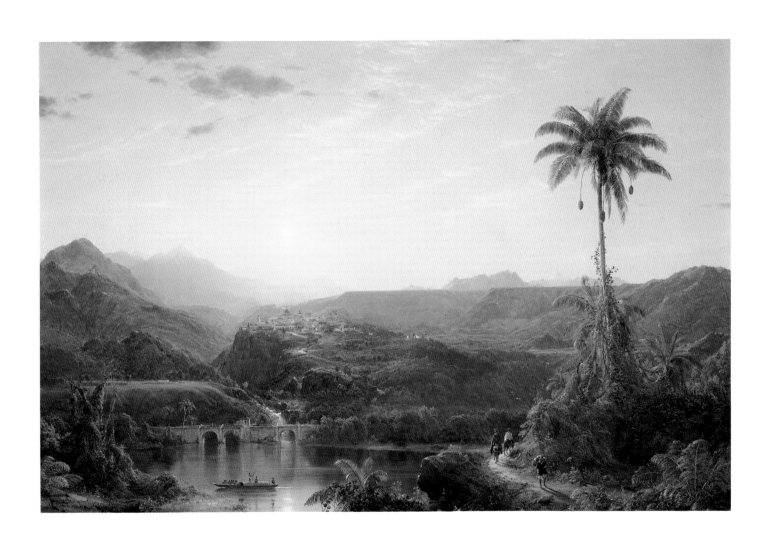

Albert Bierstadt

1830–1902

5.

Mountain Brook, about 1863
Oil on canvas, 44 x 36
Signed (at lower left): ABierstadt

RECORDED: Fitz Hugh Ludlow, *The New York Evening Post*, May 22, 1863 // Gordon Hendricks, "The First Three Western Journeys of Albert Bierstadt," *The Art Bulletin*, XLVI (Sept. 1964), p. 363 no. 244 // Gordon Hendricks, *Albert Bierstadt: Painter of the American West* (1974), p. 117

EXHIBITED: National Academy of Design, New York, 1863, *Annual Exhibition*, no. 6

EX COLL.: Oliver Kelly, Ohio, before 1900; by descent in his family, until 1990

Mountain Brook was exhibited at the National Academy of Design, New York, just prior to Bierstadt's second trip west in the spring of 1863. Although Hendricks (1964, *loc. cit.*) speculated that *Mountain Brook*, which he knew only from a description in the 1863 *Post* review, resulted from one of the artist's three western trips, the work bears a strong relationship to Bierstadt's monumental *The Emerald Pool* of 1870 (Chrysler Museum, Norfolk, Virginia), which was based on sketches made in the White Mountains of New Hampshire. Linda Ferber, who is preparing a major catalogue of Bierstadt's work, concurs, believing that *Mountain Brook* was most likely done from sketches made in New Hampshire or the Adirondacks.

Eastman Johnson

1824–1906

6.

Sugaring Off at the Camp, Fryeburg, Maine,
about 1861–65
Oil on canvas, 19¾ x 34
Signed (at lower left): E.J.; inscribed (on
the stretcher): Sugaring Off at the Camp/
Fryeburg Maine

RECORDED: Patricia Hills, *Eastman John-
son* (1972), p. 123 illus. in photo of John-
son's studio, at center

EXHIBITED: The Brooklyn Museum,
New York, 1940, *Eastman Johnson: An Amer-
ican Genre Painter*, pp. 21 no. 49, 43 nos. 49,
50, 44 no. 51, 62 no. 49, pl. XIV, cf.
pp. 43–44 nos. 50–51, 61 no. 42, 62 nos.
50, 51, as *Sugaring Off (No. 1-Unfinished)*,
lent by the Misses F. Pearl and Elizabeth
Browning // The Douthitt Gallery, New
York, 1940, *Eastman Johnson: The Keystone
Artist*, pp. 6, 10 no. 3

EX COLL.: the artist, until 1906; to estate
of the artist, 1906–07; to [American Art

Galleries, New York, sale, 1907, *The Works
of the Late Eastman Johnson, N.A.*, no. 138,
$160]; to W.B. Cogswell, 1907; the Misses
F. Pearl and Elizabeth Browning, 1940;
Clifford Smith, Glen Cove, Maine, 1940–
53; to the Rockport Public Library, Maine,
1953–78; to [Hirschl & Adler Galleries,
New York, 1978–79]; to Richard Manoog-
ian, Grosse Pointe, Michigan, 1979–84; to
private collection, 1984–90

During the early to mid-1860s, Eastman
Johnson visited Fryeburg, Maine, where he
executed a substantial number of individual
and group studies depicting the gathering
and boiling down of the maple syrup sap
and its attendant merriment. Although
the large exhibition picture for which these
studies may have been intended was never
painted, *Sugaring Off at the Camp, Fryeburg,
Maine* is apparently Johnson's largest and
most complex version of the subject. Its
bold and painterly character established
Johnson as one of the most accomplished
artists of his generation.

Martin Johnson Heade

1819–1904

7.

The Harbor at Rio de Janeiro, 1864
Oil on canvas, 18½ x 33½
Signed and dated (at lower left):
M J Heade/1864

RECORDED: Robert G. McIntyre,
Martin Johnson Heade (1948), pp. 15, 57, as
Sunset // Theodore E. Stebbins, Jr., *The Life
and Works of Martin Johnson Heade* (1975),
pp. 87, 88 fig. 50, 89, 228 no. 84 illus. //
John Wilmerding, *American Light: The
Luminist Movement, 1850–1875* (1980),
p. 117 fig. 122

EXHIBITED: Academy and Salon of Fine
Arts, Rio de Janeiro, Brazil, 1864, as *Sunset*
// Museum of Fine Arts, Boston; University
of Maryland Art Gallery, College Park; and
Whitney Museum of American Art, New
York, 1969, *Martin Johnson Heade*, no. 21
illus. // Hirschl & Adler Galleries, New
York, 1970, *Forty Masterworks of American
Art*, no. 23 illus. // Hirschl & Adler Gal-
leries, New York, 1971, *Reynolda House:
American Paintings*, pp. 30–31 fig. 14, 55
no. 14 // Hirschl & Adler Galleries, New
York, 1973, *Retrospective of a Gallery:
Twenty Years*, no. 54 illus. // Hirschl &
Adler Galleries, New York, 1977, *A Gallery
Collects*, no. 26 illus. in color, detail illus. in
color on cover

EX COLL.: purchased from the artist by
Governor Henry Lippitt, Providence,
Rhode Island, about 1866; by descent to
his grandson, C. Richard Steedman,
Providence, until 1970; to [Hirschl &
Adler Galleries, New York, 1970]; to
Reynolda House, Winston-Salem, North
Carolina, 1970–77; to [Hirschl & Adler
Galleries, New York, 1978]; to Richard
Manoogian, Grosse Pointe, Michigan,
1978–84; to private collection, 1984–90

Heade made three trips to South America
during the 1860s. It was during his first
trip in 1863–64 that *The Harbor at Rio de
Janeiro* was painted. Prior to this time,
Heade had received little or no public
recognition. But after this picture and
others were exhibited at the Academy and
Salon of Fine Arts in Rio in 1864, Pedro II,
emperor of Brazil, honored the artist with
the title of "Knight of the Order of the
Rose." *The Harbor at Rio* is one of Heade's
most complex landscapes and ranks as one
of the major landmarks of his career.

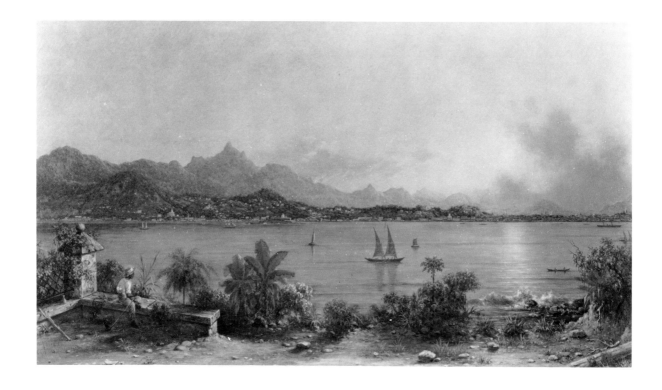

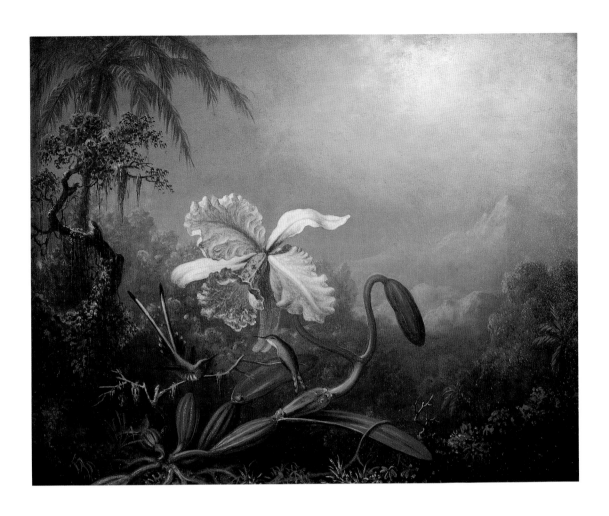

Martin Johnson Heade

1819–1904

8.

Two Hummingbirds by an Orchid, 1873 or 1875
Oil on panel, 15 ½ x 20
Signed and dated (at lower right):
187[3 or 5] / M J HEADE

RECORDED: letter, Theodore E. Stebbins, Jr., Museum of Fine Arts, Boston, Oct. 16, 1989 (Hirschl & Adler archives) // cf. Theodore E. Stebbins, Jr., *The Life and Works of Martin Johnson Heade* (1975), pp. 140 fig. 76, 238–39 nos. 133–37 illus.

EX COLL.: Frances Cote, Preston, Connecticut, until 1989

In 1870, Martin Johnson Heade took his third trip to South America, stopping along the way in Panama and Jamaica. Upon his return to New York the following year, he began a remarkable series of paintings depicting orchids and hummingbirds in their natural settings, a subject to which he would devote considerable time for the rest of his life. Although the date on this painting is difficult to read—it is either 1873 or 1875—it clearly relates to Heade's earliest depictions of the subject. Like this example, they are painted on wood panel, which helps to give them an even greater intensity of line and form.

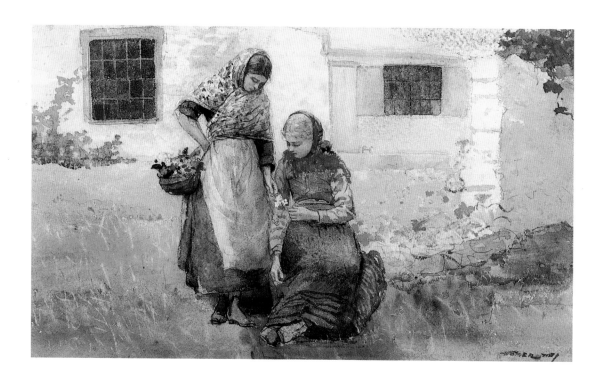

Winslow Homer

1836–1910

9.

Picking Flowers, 1881
Watercolor, gouache, and pencil on paper,
10 x 16½
Signed (at lower right): Homer [illeg.]

RECORDED: Theodore Bolton, "Watercolor by Winslow Homer: Critique and Catalogue," *Fine Arts* (April 1932), as *Two Young Women on the Grass Before a Stone Cottage*

EXHIBITED: Wildenstein & Co., New York, 1949, *Drawings through Four Centuries*, no. 68, as *Two Girls Admiring Flowers* // Allied Arts Association, Houston, 1952, no. 22 // Hirschl & Adler Galleries, New York, 1973, *Retrospective of a Gallery: Twenty Years*, no. 57, as *Girls Picking Flowers*

EX COLL.: the artist; by gift to S.T. Preston; to his niece, Mrs. William A. Preston, New Hampshire; to [M. Knoedler & Co., New York]; to Edward Coykendall, Kingston, New York; to [Victor Spark, New York]; to [Wildenstein & Co., New York, by 1949]; Arthur Vining Davis; private collection, until 1964; to [Hirschl & Adler Galleries, New York, 1964–65]; to private collection, 1965

In the spring of 1881, Homer traveled to the small fishing village of Cullercoats, near Tynemouth, England, where he lived and worked until the fall of 1882. His stay there was one of the most productive periods of his career, and the fisherfolk he encountered continued to inspire his work well after he had returned to America. *Picking Flowers* was most likely executed early in Homer's stay in England; unlike his later, more somber Tynemouth scenes, this work displays the bright colors and effects of light seen in Homer's Gloucester watercolors of the preceding year.

Picking Flowers will be included in the CUNY/Goodrich/Whitney catalogue raisonné of the artist's work, now in preparation.

Winslow Homer

1836–1910

10.

Fresh Flowers, 1885
Watercolor on paper, 14¼ x 20¼
Signed and dated (at lower right):
Winslow Homer 1885

RECORDED: William C. Church, "A Midwinter Resort," *The Century Magazine*, XXXIII (Feb. 1887), p. 501 illus. at bottom right, as *A Flower-Seller* // Patti Hannaway, *Winslow Homer in the Tropics* (1973), pp. 90–91, as *A Flower Seller* // Gordon Hendricks, *The Life and Work of Winslow Homer* (1979), pp. 180–81, cf. p. 308 no. CL-418 illus.

EXHIBITED: Upstairs Gallery, The Century Association, New York, 1885, *Winslow Homer: Thirty-six Water Colors—West Indian Studies* (no cat.) // Reichard & Company, New York, 1885, *Watercolors by Winslow Homer*, no. 16 // Doll & Richards, Boston, 1886, *Watercolors by Winslow Homer*, no. 11

EX COLL.: the artist, 1885–86; to [Doll & Richards, Boston, 1886]; to Mrs. Alice Mason, 1886; to her daughter, Mrs. Edward Balfour, Balbirnie, Scotland; to her daughter, Lady Buxton; to her nephew, Peter Balfour (grandson of Mrs. Edward Balfour); to his son, until 1989; to [Hirschl & Adler Galleries, New York, 1989]; to private collection, 1989–90

Fresh Flowers dates from Homer's first visit to the Caribbean, between December 1884 and February 1885, and was commissioned by *The Century Magazine* to illustrate an article on Bahamian history (Church, *op. cit.*, pp. 499–506). The intense sunlight and bright colors of the Bahamas led to a marked change in Homer's style, from the restrained, muted, blotted watercolors that he had executed in England and in Maine just prior to his Caribbean trip, to the vibrant watercolors that were to characterize his later years.

This watercolor will be included in the CUNY/Goodrich/Whitney catalogue raisonné of the artist's work, now in preparation.

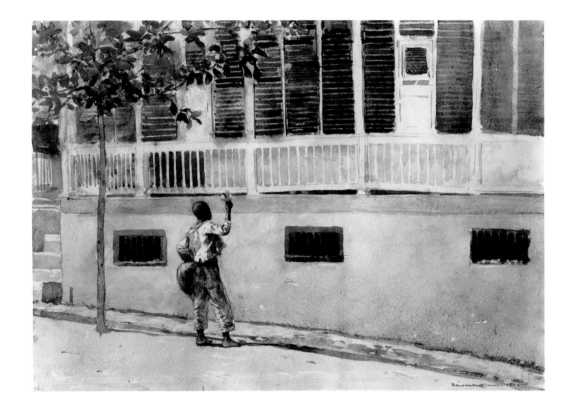

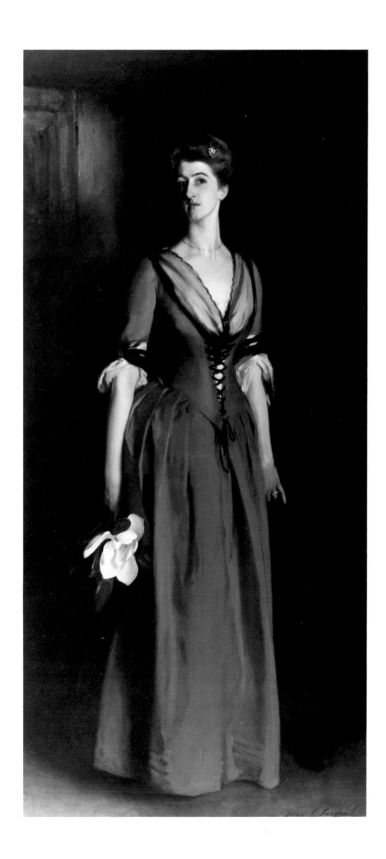

John Singer Sargent

1856–1925

Portrait of Mrs. Albert Vickers, 1884
Oil on canvas, 83¾ x 39¹³⁄₁₆
Signed (at lower right): John S. Sargent

RECORDED: William Howe Downes, *John S. Sargent: His Life and Work* (1925), p. 138 // Evan Charteris, *John Sargent* (1927), pp. 68, 259, as dated 1886 // Richard Ormond, *John Singer Sargent: Paintings, Drawings, Watercolors* (1970), pp. 39, 241 // Carter Ratcliff, *John Singer Sargent* (1982), pp. 89, 94 // Coe Kerr Gallery, New York, *Sargent at Broadway: The Impressionist Years* (1986), p. 37 // Stanley Olson, *John Singer Sargent: His Portrait* (1986), p. 113

EXHIBITED: Paris Salon, 1885, *Exposition Officielle*, p. 193 no. 2191, as *Portrait de Mme. V. . .* // Royal Academy, London, 1886, *The One Hundred and Eighteenth Annual Exhibition*, p. 19 no. 195 // Royal Academy, London, 1926, *Exhibition of Works by the Late John S. Sargent, R.A.*, p. 62 no. 411, 78 illus., lent by V.C. Vickers, Esq.

EX COLL.: Albert Vickers, Sussex, England; by descent to his son Vincent Cartwright Vickers, Esq., Royston, Hertsfordshire, England, 1926; to The Late Honorable Lady Gibbs, C.B.E., Berkshire, England, until 1989

Sargent's *Portrait of Mrs. Albert Vickers*, painted while the artist was visiting the Vickers family at their home, Lavington Rectory, near Petworth, in Sussex, focuses on the carefully studied face and regal stature of the subject. It was the first formal portrait Sargent executed after the scandal created by the exhibition of his *Portrait of Mme. Gautreau* (*Madame X*) (The Metropolitan Museum of Art, New York) in Paris in the spring of 1884.

John Singer Sargent

1856–1925

12.

Portrait of the Countess A. (Countess Clary Aldringen), 1896
Oil on canvas, 90 x 48
Signed and dated (at lower left): John S. Sargent 1896

RECORDED: William Howe Downes, *John S. Sargent: His Life and Work* (1925), p. 181, cf. p. 148 // Evan Charteris, *John Sargent* (1927), p. 265 // letter, Duchess of Portland, Welbeck Abbey, Worksop, England, to David McKibbin, Boston, June 2, 1947 (Hirschl & Adler archives) // letter, Countess Henri de Baillet Latour, Brussels, daughter of the sitter, to David McKibbin, Sept. 22, 1948 (Hirschl & Adler archives)

EXHIBITED: New Gallery, London, England, 1896 // Société Nationale des Beaux-Arts, Paris, 1898, *Exposition de 1898 Catalogue Illustré*, no. 1115

EX COLL.: the sitter, until 1930; to her daughters, Countess Henri de Baillet Latour and her sister, 1930–45; appropriated by the Czechoslovakian government in Teplitz Schonau, Czechoslovakia, in 1945; private collection, Sweden, about 1960; by descent in the family, until 1988

Sargent's unsurpassed skill as a portrait painter reached its pinnacle during the 1890s. Countess Therese Kinsky (1867–1930), wife of Count Siegfried Clary Aldringen, the Austrian Minister to England between 1895 and 1897, sat for Sargent at the urging of her friends, the Duke and Duchess of Portland. The resultant portrait, depicting the subject in one of the infinite number of different poses used by Sargent to ensure variety in his portrait commissions, is a consummate example of Edwardian portraiture, capturing the elegance of the Countess Aldringen through her regal stance and the shimmering surfaces of her white dress.

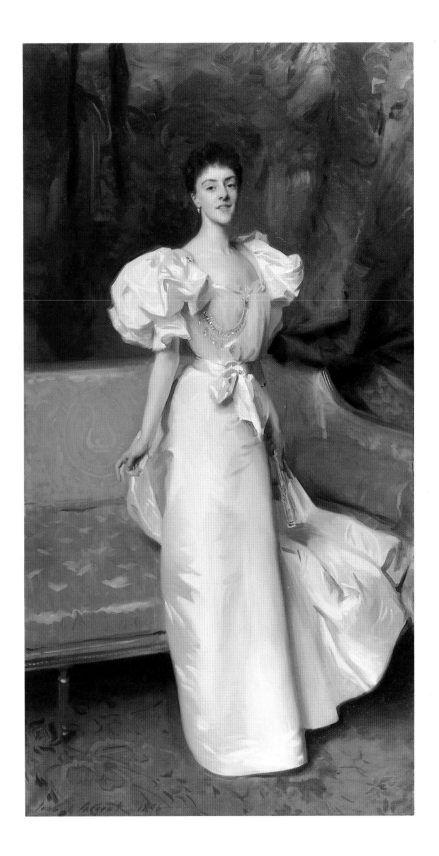

William Merritt Chase
1849–1916

13.

Gravesend Bay, about 1888
Pastel on paper, 19¼ x 29½
Signed (at lower left): Wm. M. Chase

RECORDED: "Pastel Exhibition in New York," *The New York Times,* May 5, 1890, p. 4 // Ronald G. Pisano, *Long Island Landscape Painting 1820–1920* (1985), pp. 112, 115 illus. in color

EXHIBITED: Hermann Wunderlich & Co., New York, 1890, *Fourth Exhibition of the Painters in Pastel,* no. 4 // Henry Art Gallery, University of Washington, Seattle, and The Metropolitan Museum of Art, New York, 1983–84, *A Leading Spirit in American Art: William Merritt Chase, 1849–1916,* p. 76 illus. in color

EX COLL.: Mr. and Mrs. Robert P. McDougal, Orange, New Jersey, 1890s; by descent in the family, until 1981; to [Sotheby's, New York, May 29, 1981, sale 4628, no. 14 illus. on cover in color]; to Prentis Tomlinson, Houston; Richard Manoogian, Grosse Pointe, Michigan

Gravesend Bay depicts a fashionable scene of domestic leisure against the background of New York Harbor. In this softly colored pastel, Chase employs the lighter palette he had begun to use during the 1880s, after he had become acquainted with the Impressionists and started working out-of-doors.

This pastel will be included in Ronald G. Pisano's forthcoming catalogue raisonné of the artist's work.

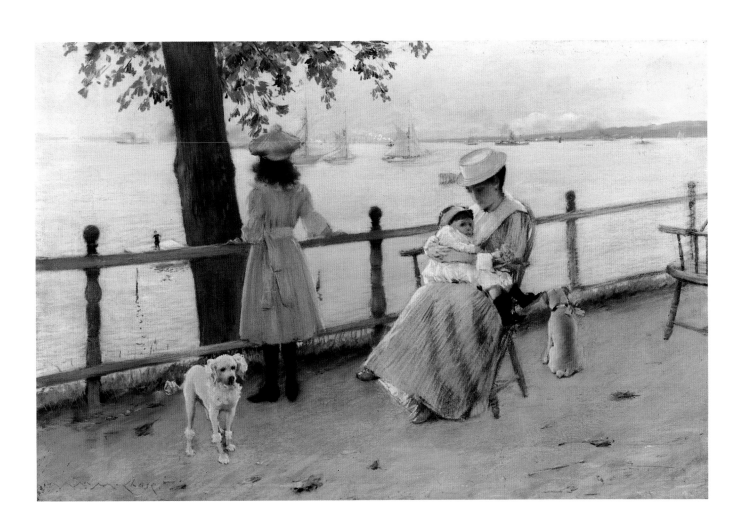

Mary Cassatt

1845–1926

14.

Portrait of a Young Woman, about 1898
Pastel on paper, 16^{15}/$_{16}$ x 22 5/$_{8}$
Signed (at lower left): Mary/Mary Cassatt

Although Mary Cassatt's first pastels date
from about 1868, shortly before she came
under the tutelage of Edgar Degas, she
achieved her greatest mastery of the
medium during the 1890s. In fact, on her
1898 trip to the United States she brought
only her pastels with her as she was begin-
ning to use the medium with increasing
frequency. This pensive portrait incorpo-
rates many of the hallmarks of Cassatt's
mature style. The female sitter is rendered
in complementary colors of turquoise and
orange in a cut-off, asymmetrical pose
inspired by Japanese prints. The deft use of
line records an accurate image of the young
woman while the vivid color and bold
strokes convey something of her youthful
demeanor.

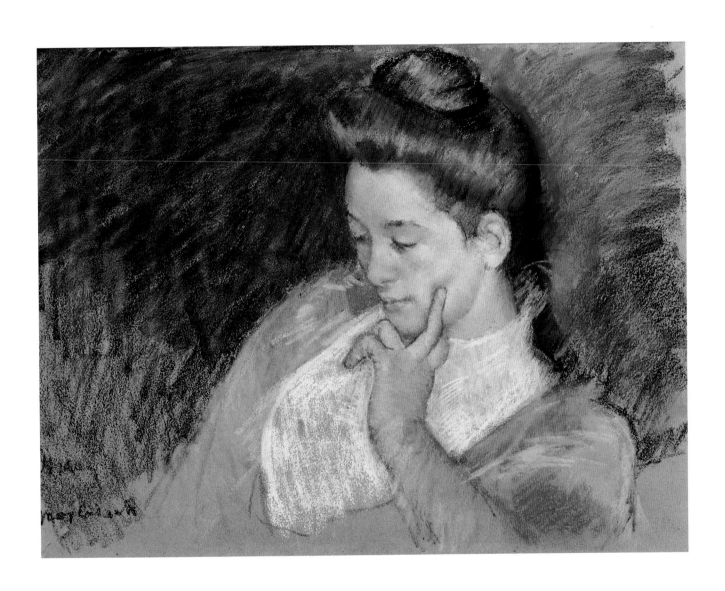

Thomas Eakins

1844–1916

15.

Portrait of John B. Gest, 1905
Oil on canvas, 40 x 30
Signed and dated (at lower right):
EAKINS/1905

RECORDED: "Catalogue of the Works of
Thomas Eakins," *The Pennsylvania Museum
Bulletin*, XXV (March 1930), p. 31 no. 287
// Lloyd Goodrich, *Thomas Eakins: His Life
and Work* (1933), pp. 201–02 no. 426, pl. 67
// Sylvan Schendler, *Eakins* (1967), pp. 181–
82, fig. 86 // Gordon Hendricks, *The Life
and Work of Thomas Eakins* (1974) pp. 244,
258, pl. 46 in color // Lloyd Goodrich,
Thomas Eakins (1982), II, pp. 61, 205,
225, 232, 233 fig. 257

EXHIBITED: The Metropolitan Museum
of Art, New York, 1917, *Loan Exhibition of
the Works of Thomas Eakins*, p. 12 no. 52 illus.
// Pennsylvania Academy of the Fine Arts,
Philadelphia, 1917–18, *Memorial Exhibition
of the Works of the Late Thomas Eakins*, p. 89
no. 72 illus.

EX COLL.: Fidelity Trust Company,
Philadelphia, 1905–90

Eakins began to concentrate on portraiture
after his dismissal from the Pennsylvania
Academy of the Fine Arts, Philadelphia, in
1886. During the 1890s and until about
1906, he executed many portraits of his
family, his friends, and people he admired.
These late portraits are considered to be
among his best works. The portrait of
John B. Gest (1823–1907), president of the
Fidelity Trust Company of Philadelphia
from 1890 to 1900, was one of Eakins' few
commissioned works during this period and
ranks as one of his most incisive depictions
of character.

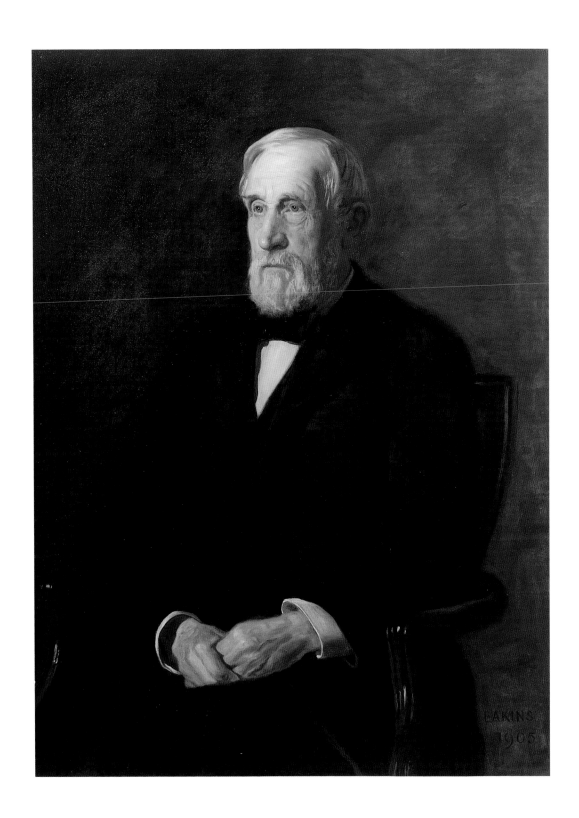

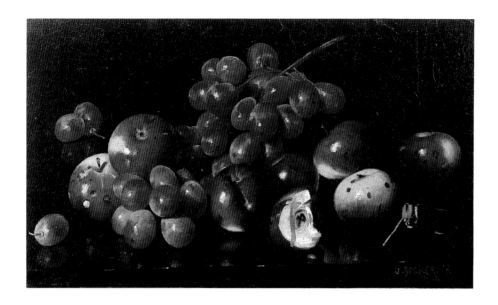

Joseph Decker

1853–1924

16.

Still Life with Crab Apples and Grapes, 1888
Oil on canvas, 8 x 14
Signed and dated (at lower right):
J. DECKER. 88.

EX COLL.: Dr. James Piccolo, New Haven,
until 1972; to Yale University Art Gallery,
New Haven, until 1987

Although Joseph Decker's oeuvre includes
landscapes, genre scenes, and portraits, he
is best known for his still lifes. His early
style, which usually depicted fruit or nuts
in natural settings, was often described by
contemporary critics as being too sharply
contoured. The artist apparently took this
criticism to heart, and his later work
evolved into tabletop arrangements ren-
dered in a much softer manner. It is, how-
ever, for his early pictures such as *Still Life
with Crab Apples and Grapes* that he earned
his reputation as one of the best American
still-life painters of his time.

Maurice B. Prendergast

1859–1924

17.

Afternoon Stroll, Summer, about 1918–23
Oil on canvas, 20 x 24
Signed (at lower right): Prendergast

EX COLL.: private collection, before 1940;
by descent in the family, until 1990

This previously unrecorded painting
relates to a series of oils and pastels of the
same period that depict New England
scenes. Prendergast renders the stream of
pedestrians on the sidewalk with bold
colors and lively brushstrokes that suggest
strollers in motion. This work will be
included in the addenda to the Clark,
Matthews, Owens *Maurice and Charles
Prendergast Catalogue Raisonné.*

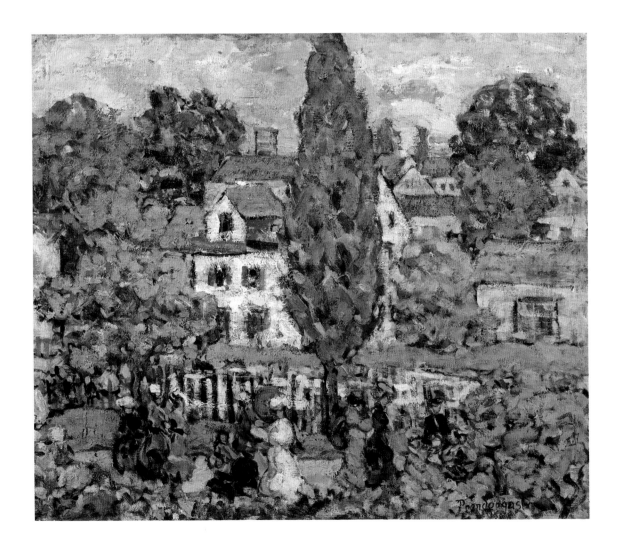

TWENTIETH-CENTURY PAINTINGS

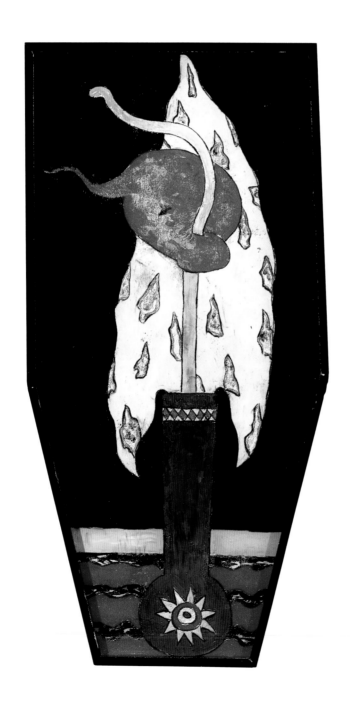

Marsden Hartley

1878–1943

18.

Red Calla in Blue Vase, 1917
Oil on glass, 21½ x 10¾

EXHIBITED: Indiana University Art Museum, Bloomington, and Colby College Art Museum, Waterville, Maine, 1965, *The Collection of Robert & Mimi Laurent*, no. 40 // Portland Museum of Art, Maine, 1977–78, *Marsden Hartley: Paper and Paint* (no cat.) // Whitney Museum of American Art, New York; The Art Institute of Chicago; Amon Carter Museum, Fort Worth; and University Art Museum, University of California, Berkeley, 1980–81, *Marsden Hartley*, pp. 67 pl. 29, 216 no. 45, cf. pp. 56–57 // State of Maine Gallery, Portland Museum of Art, Maine, 1983–84, *Grand Opening: State of Maine Collection* (no cat.) // The Becker Gallery, Bowdoin College Museum of Art, 1987, *Marsden Hartley: Variable Genius* (no cat.)

EX COLL.: the artist; Robert Laurent, Brooklyn, New York, and Ogunquit, Maine, until 1970; to his son and daughter-in-law, Maine, 1970–89

Red Calla in Blue Vase is an extraordinary example of Hartley's glass paintings, executed during the summer and fall of 1917 in Ogunquit, Maine, and New York City. Hartley was inspired by the religious symbolism of Bavarian glass paintings, which he had begun to collect in 1914 in Germany, and by American folk art paintings on glass. *Red Calla in Blue Vase* is among the most powerful of the artist's paintings on glass and is laden with the symbolism that preoccupied Hartley throughout his career: the triangular cloth framing the red calla alludes to nature's sublimity, while the calla lily itself connotes male and female sexuality.

This painting will be included in Gail Levin's catalogue raisonné of the artist's work, now in preparation.

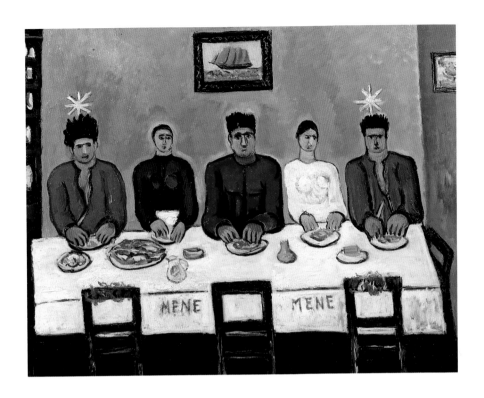

Marsden Hartley

1878–1943

19.

Fisherman's Last Supper, 1938
Oil on academy board, 22 x 28

RECORDED: Elizabeth McCausland, *Marsden Hartley* (1952), pp. 9, 46, 51 illus., 71 // Hudson Walker, "Marsden Hartley: Recollections of the Artist in a Tape-Recorded Interview Conducted by Elizabeth McCausland," *Journal of the Archives of American Art*, VIII (Jan. 1968), p. 18 // E. Gary Gillespie, "A Collateral Study of Selected Paintings and Poems from Marsden Hartley's Maine Period" (Ph.D. dissertation, Ohio University, Athens, 1974), pp. 88, 148–50, cf., 147, 150–53

EXHIBITED: Hudson D. Walker Gallery, New York, 1939, *Marsden Hartley: 25th One Man Show*, no. 5 // The Friends of Contemporary Art, Inc., and The American Association of University Women, Coral Gables, Florida, 1949, *A Retrospective Exhibition of Paintings by Marsden Hartley*, no. 12 // Shore Galleries, Boston, 1962, *A Loan Exhibition to Benefit The Heart Fund*, no. 29 // American Federation of Arts traveling exhibition, 1966–67, *Late Works of Marsden Hartley* // Whitney Museum of American Art, New York; The Art Institute of Chicago; Amon Carter Museum, Fort Worth; and University Art Museum, University of California, Berkeley, 1980–81, *Marsden Hartley*, pp. 100–01, 114 pl. 54, 115–16, 219 no. 82, cf. 114 pl. 55, 122, 220 no. 91 // Salander O'Reilly Galleries, New York, 1985, *Marsden Hartley: Paintings and Drawings*, no. 40 illus. // Mount Saint Vincent University Art Gallery, Halifax, Nova Scotia, and Art Gallery of Ontario, Toronto, 1987–88, *Marsden Hartley and Nova Scotia*, cover illus. in color, pp. 14 illus., 67–68 no. 10

EX COLL.: the artist, 1938–41; to Mr. and Mrs. Hudson D. Walker, 1941–78; to Mrs. Ione Walker, 1978; to estate of Mrs. Ione Walker, until 1988

Fisherman's Last Supper stands as a major icon of Hartley's late work. The painting was originally conceived as a preliminary study for a mural that would celebrate the devoutness of the Mason family with whom Hartley lived in Nova Scotia. However, after the tragic drowning of the two sons, Alty and Donny, the composition took on a more personal spirituality. This first version of the subject was executed in Maine, during the summer of 1938 (a second version was painted in 1940–41, collection of Roy R. Neuberger, New York).

Arthur B. Carles

1882–1952

20.

Sails, about 1925
Oil on canvas, 24 x 29½
Inscribed (on the back): ARTHUR B.
CARLES/TO/Helen D. Taylor 1930

RECORDED: Barbara Wolanin, "Arthur B.
Carles, 1882–1952: Philadelphia Modernist"
(Ph.D. dissertation, University of Wisconsin, Madison, 1981), pp. 405, 474 no. IVC-17

EXHIBITED: National Collection of Fine
Arts, Washington, D.C., and the Pennsylvania Academy of the Fine Arts, Philadelphia, 1975, *Pennsylvania Academy Moderns: 1910–1940*, no. 12 illus., as dated about 1930 // David Winton Bell Gallery, Brown University, Providence, Rhode Island, 1989, *Over Here: Modernism, The First Exile 1914–1919*, no. 14 illus., as dated about 1919

EX COLL.: the artist; to his student Helen
D. Taylor, Philadelphia, 1930; to her
husband, Dr. Norman Taylor; to [Bert
Baum Gallery, Sellersville, Pennsylvania,
1960]; to Mr. and Mrs. Leo Asbel, Paris;
to private collection, until 1990

As a teacher at the Pennsylvania Academy
of the Fine Arts, Arthur B. Carles was one
of the leading exponents of modernism in
Philadelphia during the 1920s. His work
reflects the influence of Orphism and
Synchromism, which he had encountered
in Paris in 1912–13. In its complete abstraction of form, *Sails* is an unusual example of
Carles' work of this period.

Arthur Dove

1880–1946

21.

Image, 1929
Oil on canvas, 12 x 16
Signed (at lower right): Dove

RECORDED: Ann Lee Morgan, *Arthur Dove: Life and Work, with a Catalogue Raisonné* (1984), p. 170 no. 29.8

EXHIBITED: An American Place, New York, 1930, *Arthur G. Dove,* no. 11 // The Downtown Gallery, New York, 1956, *Special Exhibition of Paintings by Dove,* no. 7 // Fort Worth Art Center, 1968, *Arthur Dove*

EX COLL.: [An American Place, New York, 1929–46]; to [The Downtown Gallery, New York, 1946–70]; to Mr. Dorment, in 1970; [Kennedy Galleries, New York]; to private collection, Cincinnati, until 1989

Although *Image* exhibits many elements of Dove's signature style, it is perhaps one of his most eccentric paintings of the late 1920s. As usual, his inspiration is taken directly from nature, but the forms are less discernible, the brushstrokes more spontaneous, and the colors more bizarre than in most of the other paintings he created during this period.

Edward Hopper

1882–1967

22.

Lombard's House, 1931
Watercolor, 20 x 27⅞
Signed (at lower right): EDWARD
HOPPER

RECORDED: Edward Hopper, Record
Book I (Special Collections, Whitney
Museum of American Art, New York),
p. 75: "Delivered to Rehn Gallery October
1931: *Lombard's House*. Blond & very clear.
White house, picket fence, Little tree in
front of house, trunk bent to side. Tarred
road." // Whitney Museum of American
Art, New York, *Whitney Museum of Amer-
ican Art: History, Purpose, Activities—Cata-
logue of the Collection to June 1937* (1937),
no. 27 // Jean Gillies Mueller, "The Time-

less Space of Edward Hopper" (Ph.D.
dissertation, Northwestern University,
Evanston, Illinois, 1970), p. 141

EXHIBITED: Whitney Museum of Ameri-
can Art, New York, 1933, *First Biennial
Exhibition of Contemporary American Sculpture,
Watercolors and Prints*, no. 93 // The Amer-
ican Pavilion, Venice, 1934, *XIX Venice
Biennale*, no. 75 // M.H. de Young Memo-
rial Museum, California Palace of the
Legion of Honor, San Francisco, 1935,
Exhibition of American Painting, no. 353 //
Carnegie Institute, Pittsburgh, 1937, *An
Exhibition of Paintings, Water Colors, and
Etchings by Edward Hopper*, no. 50 // The
Metropolitan Museum of Art, New York;
Santiago Club, Mexico City; Lima, Peru;
and Quito, Ecuador, 1941, *La Pintura
Contemporanea Norteamericana*, p. 132 illus. //
Des Moines Art Center, Iowa, 1952, *The
Artist's Vision*, no. 43 // The Currier Gallery
of Art, Manchester, New Hampshire, 1959,

*Watercolors by Edward Hopper with a Selection
of His Etchings*, no. 23

EX COLL.: [Frank K.M. Rehn Gallery,
New York]; to Whitney Museum of Amer-
ican Art, New York, 1933–50; to [Frank
K.M. Rehn Gallery, New York, 1950]; to
Charles Bruce Gould, New Jersey, about
1955; to estate of Charles Bruce Gould,
until 1989

As with all of Hopper's most successful
architectural subjects, the houses in this
watercolor have an almost animate quality
and read much like a group portrait. The
telephone pole, the sky, and the effects of
light and shadow all combine to make
Lombard's House a quintessential Hopper
watercolor. The large scale of the work is
somewhat rare in Hopper's oeuvre.
Lombard's House will be included in the
forthcoming catalogue raisonné of Hopper's
work as number W-267.

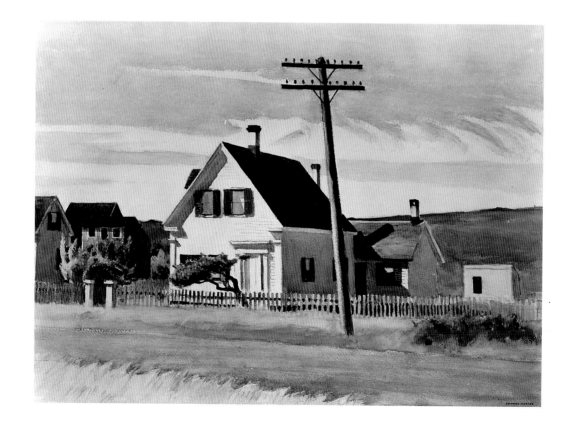

Oscar Bluemner

1867–1938

23.

Blue Above, 1933
Oil on canvas, 51 x 36
Signed (at lower right): FLORIANVS

RECORDED: Jeffrey R. Hayes, "Oscar Bluemner: Life, Art, and Theory" (Ph.D. dissertation, University of Maryland, College Park, 1982), pp. 370–71, 377, 398–99 notes 196–202, 535 fig. 105, 540 fig. 110 // Jeffrey R. Hayes, "Oscar Bluemner's Last Landscapes: 'The Musical Color of Fateful Experience,'" *Art Journal*, XLIV (Winter 1984), pp. 358–59 fig. 13

EXHIBITED: Marie Harriman Gallery, New York, 1935, *New Landscape Paintings by Oscar F. Bluemner, Compositions for Color Themes*, no. 2 // The University Gallery, University of Minnesota, Minneapolis, 1939, *Oscar Florianus Bluemner*, no. 5 // Graham Gallery, New York, 1967, *Oscar Bluemner*, no. 14 // Hirschl & Adler Galleries, New York, 1982–83, *Lines of Different Character: American Art from 1727 to 1947*, pp. 96–97 no. 78 illus. // Hirschl & Adler Galleries, New York, 1986, *Modern Times: Aspects of American Art, 1907–1956*, p. 17 no. 8 illus. in color // The Corcoran Gallery of Art, Washington, D.C., 1988, *Oscar Bluemner: Landscapes of Sorrow and Joy*, p. 74 no. 111 illus.

EX COLL.: the artist; [James Graham & Sons, New York, 1967]; [Harry Spiro, New York, 1969–70]; private collection, New York, until 1982

One of the last and largest of Bluemner's oils, *Blue Above* typifies the artist's mature style. It was developed from one of sixteen watercolor studies on what Bluemner called the theme of "free motives of Vermilion and Blue [in which] the Idea of Color and Action is parallel to the music of Prokofiev, Scriabin, and R. Strauss" (cf. Hayes, 1984, *op. cit.*, p. 358).

Georgia O'Keeffe

1887–1986

24.

Red and Orange Hills, 1938–39
Oil on canvas, 19 x 36
Signed, dated, and inscribed (on the back):
My Red Hills—1938–9/Georgia O'Keeffe

RECORDED: Georgia O'Keeffe, *Georgia O'Keeffe* (1976), no. 98 illus. in color

EXHIBITED: An American Place, New York, 1939, *Georgia O'Keeffe: Exhibition of Oils and Pastels*, no. 9 // The Denver Art Museum 1974, *Picturesque Images from Taos and Santa Fe*, pp. 162 no. 109, 166 pl. 109 // National Museum of American Art, Smithsonian Institution, Washington, D.C.; Cincinnati Art Museum; The Museum of Fine Arts, Houston; and The Denver Art Museum, 1986–87, *Art in New Mexico, 1900–1945: Paths to Taos and Santa Fe*, pp. 162, 164 pl. 189, 165, 205

EX COLL.: the artist, 1938–67; to her attorney, Judge Oliver Seth, Santa Fe, New Mexico, 1967–89

The hills depicted in this painting could be seen from O'Keeffe's home near Abiquiu, New Mexico. Although realism is at the core of O'Keeffe's vision, she focuses in closely on the subject, then crops the image to create one of her most abstract and powerful landscape compositions.

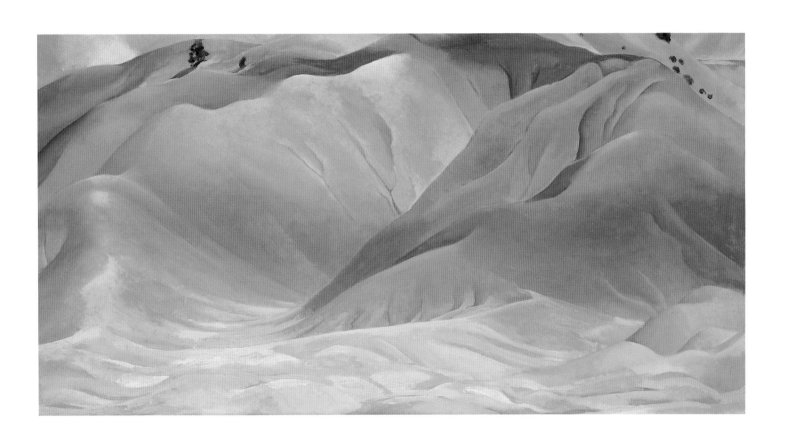

Theodore Roszak

1907–1981

25.

Musical Still Life, 1932
Painted plaster, wood, and caning,
28½ x 21 x 6
Signed and dated (on the back): T R '32

RECORDED: Joan Seeman Robinson, "The
Sculpture of Theodore Roszak: 1932–1952"
(Ph.D. dissertation, Stanford University,
1979), pp. 31, 33, 231, 263 fig. 42

EXHIBITED: Wichita Art Museum, Kan-
sas, 1986, *Theodore Roszak: The Early Works,
1929–1943,* pp. 51 pl. VII in color, 64 //
Hirschl & Adler Galleries, New York,
1989, *Theodore Roszak: Paintings and Draw-
ings from the Thirties,* pp. 52 fig. 50 in color,
79 no. 68

EX COLL.: estate of the artist, until 1989;
to private collection, 1989–90

Musical Still Life is one of about eight plas-
ters that Roszak modeled while living in
Staten Island, New York, between 1931
and 1934. As one of the few surviving bas-
reliefs from this period, it marks his first
foray into sculpture that reflects his inves-
tigation of Cubism. Lacking the funds to
cast his earliest works in bronze, Roszak,
like John Storrs and John Ferren, poly-
chromed some of his plaster pieces, thereby
producing a hybrid object that was both
sculptural and painterly.

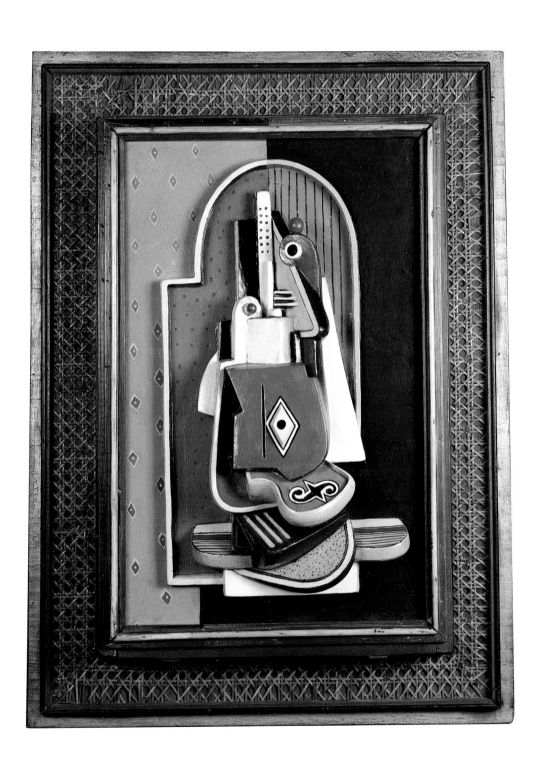

George Ault

1891–1948

26.

January Full Moon, 1941
Oil on canvas, 20 x 26
Signed and dated (at lower right):
G.C. Ault '41

RECORDED: James R. Mellow, "A Successful Escape into Night," *The New York Times*, Dec. 16, 1973, p. D25 illus. // Donald Hall, "Warming to the Cold and Snow —The Satisfactions of a New Hampshire Winter," *Harper's* (Feb. 1986), p. 53 illus.

EXHIBITED: Albany Institute of History and Art, New York, 1941, *Sixth Annual Exhibition*, no. 3 // Whitney Museum of American Art, New York, 1973, *George Ault: Nocturnes*, no. 28 illus. // Heckscher Museum, Huntington, New York, 1978, *The Precisionist Painters 1916–1949: Interpretations of a Mechanical Age*, p. 24 // Haus der Kunst, Munich, 1981–82, *American Painting 1930–1980* // Hood Museum of Art, Dartmouth College, Hanover, New Hampshire, 1986, *Winter*, no. 68 // Whitney Museum of American Art at Equitable Center, New York; Memphis Brooks Museum of Art, Tennessee; Joslyn Art Museum, Omaha; and New Jersey State Museum, Trenton, 1988–89, *George Ault*, pp. 34 no. 32 illus. in color, 53

EX COLL.: the artist; Mrs. Barbara Dickman; private collection, New York, until 1990

The dark and evocative nocturne was a compelling aspect of Ault's work. These brooding canvases, which trace their origins to the artist's New York evening scenes of 1921, stand in sharp contrast to the pristine clarity of his urban Precisionist views. Ault began painting his rural nocturnes after his move in 1937 to Woodstock, New York, where he became intrigued by the almost surreal image of barns looming large in the night sky. After completing *January Full Moon*, Ault executed a group of four related paintings depicting night views of three barns at Russell's Corners, an intersection in Woodstock about a quarter mile from his studio. These canvases are among his most haunting and dramatic images.

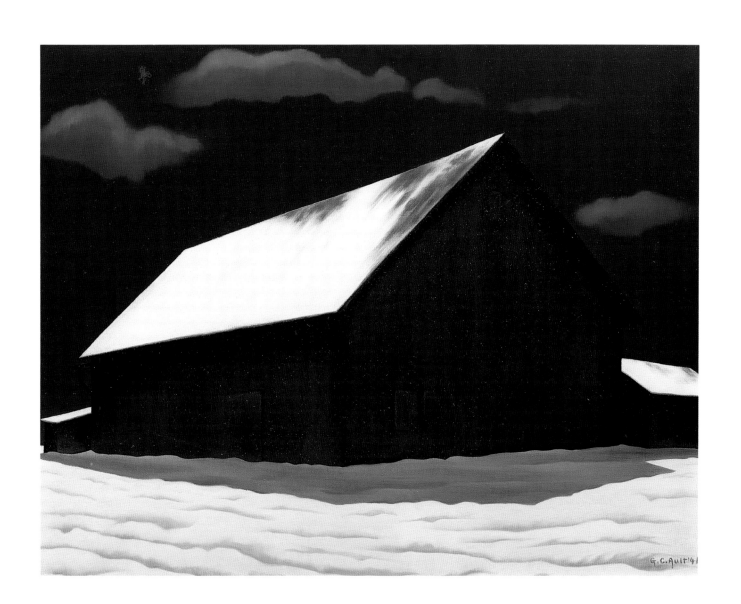

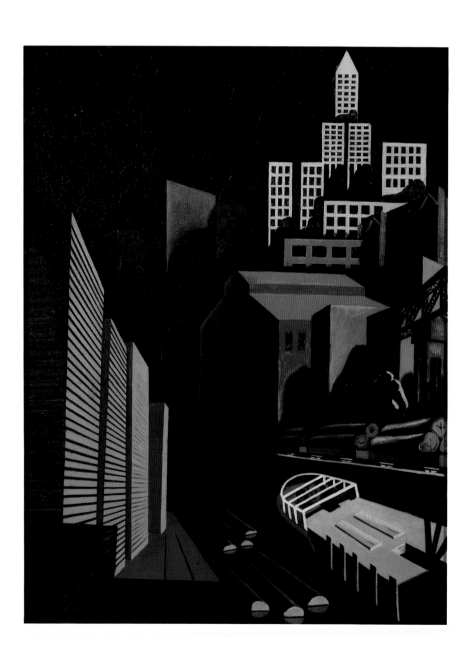

Louis Lozowick

1892–1973

27.

Seattle, about 1921–23
Oil on canvas, 24 x 18¼
Signed (at lower left): Louis Lozowick;
(on the back): Louis/Lozowick

RECORDED: cf. Virginia Carol Marquardt, "Louis Lozowick: Development from Machine Aesthetic to Social Realism, 1922–1936" (Ph.D. dissertation, University of Maryland, College Park, 1983), pp. 84–87, 164 fig. 5

EX COLL.: the artist; to private collection, 1928–89

Seattle was among the ten American cities that Lozowick painted while in Europe during the period between 1921 and 1923. Urban subjects continued to dominate his work when he returned to New York in 1924 and began a second set of city paintings, which he worked on until about 1926. This canvas is most likely the one painted in Berlin. Another version (Hirshhorn Museum and Sculpture Garden, Washington, D.C.) is thought to be later.

Charles Sheeler

1883–1965

28.

Windows, 1951
Oil on canvas, 32 x 20⅛
Signed and dated (at lower right): Sheeler
1951

RECORDED: Lillian Natalie Dochterman,
"The Stylistic Development of the Work of
Charles Sheeler" (Ph.D. dissertation, State
University of Iowa, Iowa City, 1963),
p. 489 no. 51.321 illus. // Martin Friedman,
Charles Sheeler (1975), pp. 167, 198 illus.
in color

EXHIBITED: Art Galleries, University of
California at Los Angeles; M.H. de Young
Memorial Museum, San Francisco; Fort
Worth Art Center; Munson-Williams-
Proctor Institute, Utica, New York; Penn-
sylvania Academy of the Fine Arts, Phil-
adelphia; and San Diego Fine Arts Gallery,
1954, *Charles Sheeler: A Retrospective Exhibition*,
p. 46 no. 38

EX COLL.: [The Downtown Gallery, New
York, in 1951]; to The Northern Trust
Company, Chicago, 1951–85

Windows, a brilliant Precisionist statement,
transforms into paint Sheeler's experiments
with multiple exposure photography. It also
reintroduces the New York skyscraper, a
motif that had intrigued Sheeler in the
1920s.

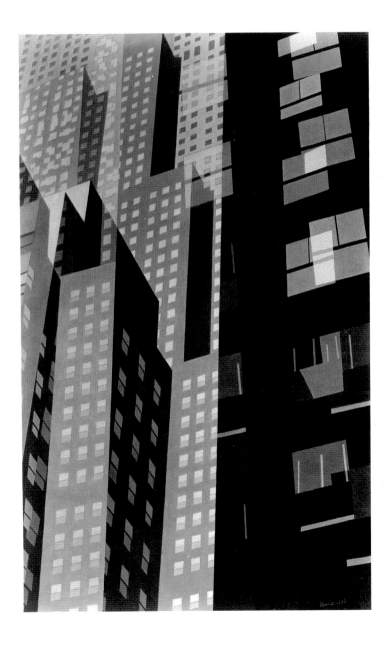

Stuart Davis

1892–1964

29.

Night Life, 1962
Oil on canvas, 24 x 32
Signed, dated, and inscribed (at upper center): S. Davis; (on the stretcher): Stuart Davis/Night Life/1962

EXHIBITED: The Downtown Gallery, New York, 1962, *Stuart Davis: Exhibition of Recent Paintings, 1958–1962*, no. 1 // The Downtown Gallery, New York, 1962, *36th Annual Spring Exhibition: The Figure*, no. 6 // Musée d'Art Moderne de la Ville de Paris; Amerika Haus, West Berlin; and London Chancery Building, London, 1966, *Stuart Davis: 1894–1964*, no. 44

EX COLL.: the artist; to [The Downtown Gallery, New York]; to private collection, 1962–89

Completed just two years before his death, *Night Life* reflects Davis' persistent interest in indigenous American subjects as well as his personal preoccupations. The bold use of sharply contrasting, dissonant colors, fractured forms, and syncopated patterns, which have their roots in European Cubism, effectively evoke the jazz age that so fascinated Davis. This painting is, in effect, the culmination of Davis' lifelong interest in cabaret themes, which he first explored in early paintings such as *The Music Hall* (1910).

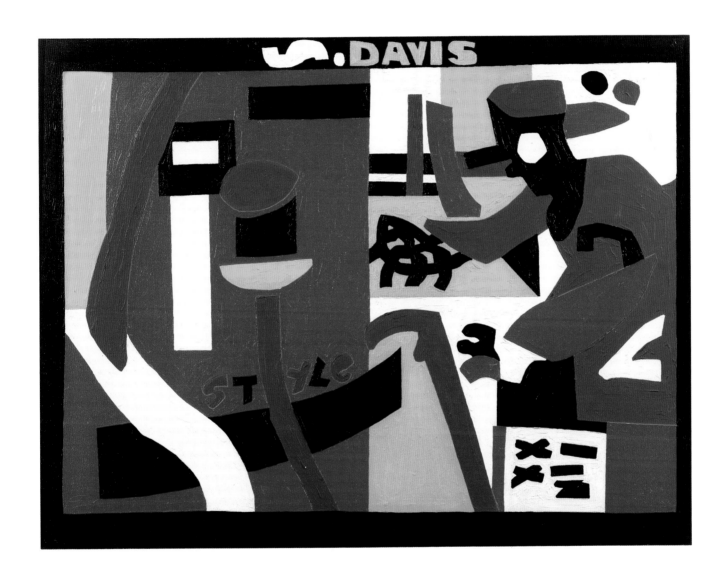

PRINTS

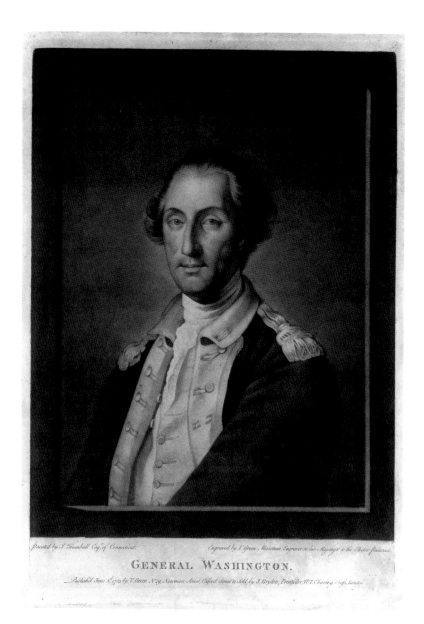

After John Trumbull

1756–1843

Engraved and published by

Valentine Green

1739–1813

30.

General Washington, 1783
Mezzotint, 14¼ x 10½

EX COLL.: The Hon. J. William Middendorf II, Washington, D.C., until 1989

This remarkably incisive portrait, cut into copper by the master engraver Valentine Green, was issued in London a scant six months after the signing of the Treaty of Paris formally ended hostilities between the United States and Great Britain. It is based upon the full-length portrait by the eminent Connecticut artist John Trumbull, who himself served as an aide-de-camp to Washington during the Revolutionary War. Of great rarity, it is among the most renowned of American eighteenth-century portrait prints.

After William Guy Wall

1792–after 1863

Engraved by John Hill

1770–1850

31.

New York from Weehawk and *New York from Heights near Brooklyn,* both 1823
Hand-colored aquatints with engraving,
each 15 ½ x 24
First states of three

John Hill, who came to the United States
from London in 1816, was one of the ear-
liest and most important printmakers to
work extensively in aquatint in this coun-
try. Over a period of twenty years in New
York and Philadelphia, Hill collaborated
with landscape watercolorists, such as the
Irish-born William Guy Wall, to create
some of the most notable views of early
nineteenth-century America. He is perhaps
best known for his influential work *The
Hudson River Portfolio,* a series of twenty
plates executed between 1821 and 1825
that became a benchmark for succeeding
printmakers. Of his single or paired prints,
these two companion views of New York
are considered his finest and are among the
most coveted of the early New York views.

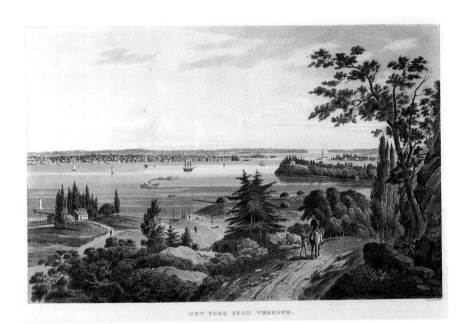

NEW YORK FROM WEEHAWK.

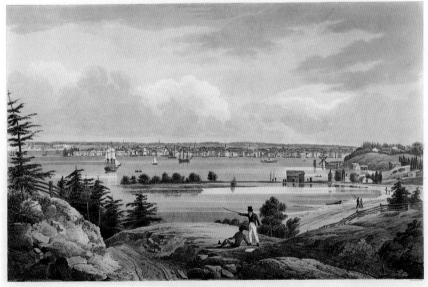

NEW YORK FROM HEIGHTS NEAR BROOKLYN.

First State of Eight

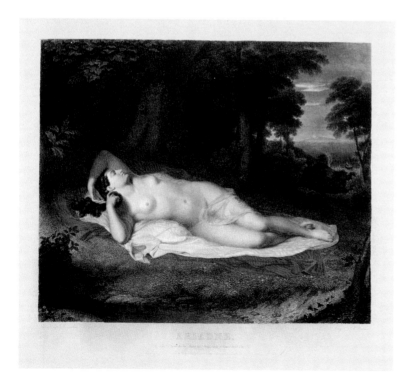

Eighth and Final State

After John Vanderlyn

1775–1852

Engraved by Asher B. Durand

1796–1886

32.

Ariadne, 1835
Engravings, 14 3/16 x 17 3/4
Six of seven proof states, plus the final state

RECORDED: The Grolier Club, New York, *The Engraved Work of Asher B. Durand* (1895), pp. 101–03, no. 237

EX COLL.: the artist; to Mr. Charles Henry Hart; Mrs. Henry C. Sturgis

Asher B. Durand is one of a number of important nineteenth-century American painters whose early training took place within the shadow of a printing press. At the age of seventeen, Durand apprenticed with the engraver Peter Maverick, with whom he would eventually form a partnership. By the time he completed *Ariadne* in 1835, he was recognized as the preeminent American engraver of his day. *Ariadne* is not only his most ambitious engraved work; it was also the last before he turned his attention exclusively to painting. The only other set of proofs known to exist is in the collection of The New York Public Library.

After John James Audubon

1785–1851

Engraved by Robert Havell

1793–1878

33.

Iceland or Jer Falcon, 1837
Hand-colored aquatint and line engraving,
35 ⅛ x 23 ½

In Audubon's *Birds of North America,* the
artist's keen observation, passion for the
natural world, and remarkable aesthetic
sensibility combined to produce one of the
world's preeminent natural history docu-
ments. Publication of the sumptuous port-
folio of 435 colorplates was a massive
undertaking without precedent and took
eleven years to complete. Audubon's *Jer
Falcon* successfully captures the noble
character of this bird, among the swiftest
of all the species. Since medieval times,
the jer has been highly prized as the most
desirable of falcons to train for the hunt.

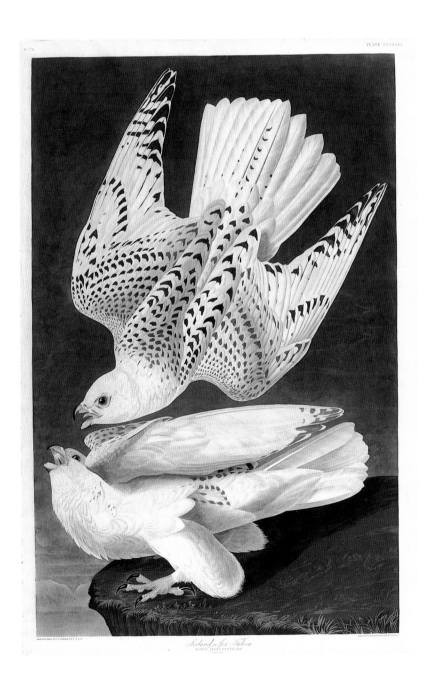

William James Bennett

1787–1844

34.

A Brisk Gale—Bay of New York, 1839
Aquatint, 19¾ x 25⅝
Engraved by Bennett after his own water-
color drawing

Bennett, who trained at the Royal Acad-
emy in London before coming to this coun-
try in 1826, was the most accomplished
artist in America to work in aquatint in the
first half of the nineteenth century. His
series of folio engravings of towns and
harbors, of which this represents an impor-
tant example, is considered the finest col-
lection of American city views ever done.

Not merely a topographical view, *A
Brisk Gale—Bay of New York* is a successful
marine subject in its own right and repre-
sents Bennett's attempt to capture the
optimism which characterized the end of
the Federal period, when the promise of
American ideals seemed to find fulfillment
in the country's busy commercial centers.

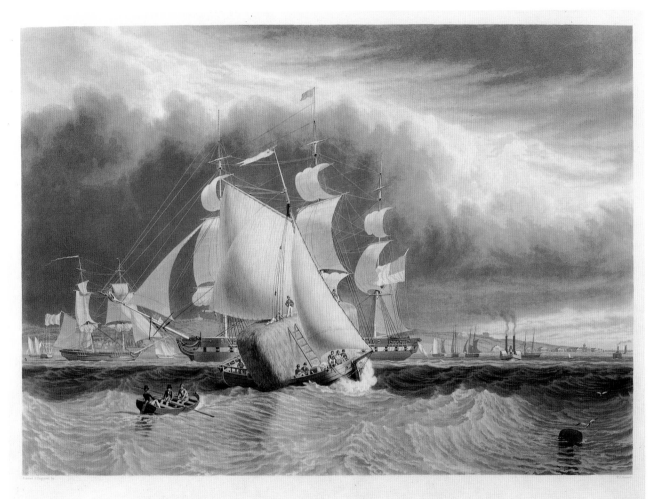

A BRISK GALE, BAY OF NEW YORK.

William Sharp

1803–1875

Lithographed by Sharp & Son,

Dorchester, Massachusetts

Printed and published for the author by

Dutton and Wentworth, Boston

35.

Victoria Regia, or The Great Water Lily of America, 1854
Opening Bud, Opening Flower, Intermediate Stages of Bloom, Complete Bloom
Color lithographs, each 15 x 21

William Sharp's plates for John Fiske Allen's *Victoria Regia, or The Great Water Lily of America* represent the culmination of more than twenty years of experimentation in color lithography. These experiments began in England, where Sharp was employed as a lithographer, and continued after his arrival in the United States in 1839. The commission—to provide six illustrations for an elephant-folio publication devoted to the giant water lily owned by Allen, an amateur botanist living in Salem, Massachusetts—gave Sharp the opportunity to demonstrate his expertise in multiple-stone color printing. Although based on a similar English portfolio, Sharp's prints surpassed the English prototype in their refined sense of color, and he endowed his flowers with a haunting, almost magical presence. The four plates included in this exhibition are regarded as among the most important and beautiful color prints made in nineteenth-century America.

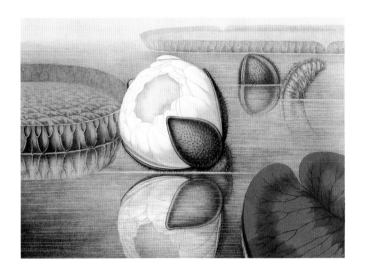

Opening Bud

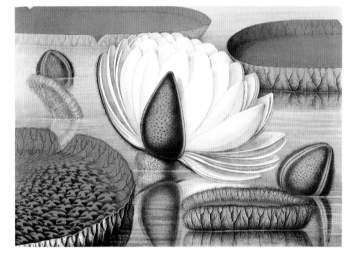

Opening Flower

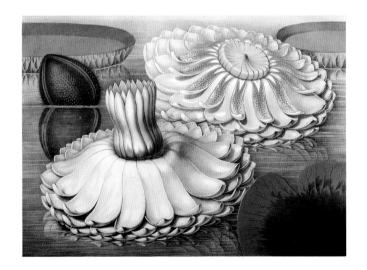

Intermediate Stages of Bloom

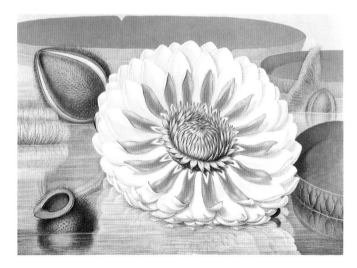

Complete Bloom

After Frances Flora Bond Palmer

About 1812–1876

Printed and published by Currier & Ives

36.

The "Lightning Express" Trains Leaving the Junction, 1863
Lithograph with hand coloring, 17 ½ x 27 ¾

The firm of Currier & Ives was started in 1857 when James Merrit Ives became a partner in the twenty-two-year-old lithography shop of Nathaniel Currier. From that point on the firm produced many of the most popular and important lithographs of the day, based on works by such artists as Frances (Fanny) Flora Bond Palmer, Louis Maurer, Charles Parsons, and George Henry Durrie.

While the firm employed a large staff of professional lithographers and colorists, many of the artists, most notable among them Fanny Palmer and Charles Parsons, delineated their own designs on the stone. This impression of *The "Lightning Express" Trains,* outstanding for its color and condition, is among the most valued of all Currier & Ives images.

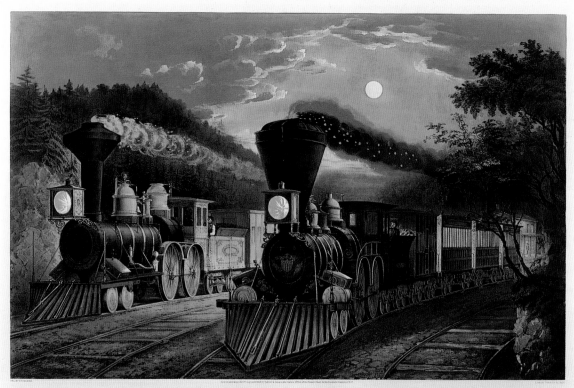

THE "LIGHTNING EXPRESS" TRAINS.
"Leaving the Junction"

After William Michael Harnett

1848–1892

Printed and published by

Frank Tuchfarber, Cincinnati

Active 1870–90

37.

The Old Violin, 1887
Chromolithograph, 35 x 24

Among the most celebrated of nineteenth-century American color lithographs is that of the master printer Frank Tuchfarber after Harnett's 1886 still life titled *The Old Violin*. Tuchfarber, founder of the Cincinnati Symphony, purchased the painting from the artist in 1886 and published the print a year later, employing seventeen different stones in an effort to reproduce the luster of the original oil. An oak frame carved to enhance the trompe l'oeil effect appears to have been an option for the original subscribers and completes the cachet of this remarkable work.

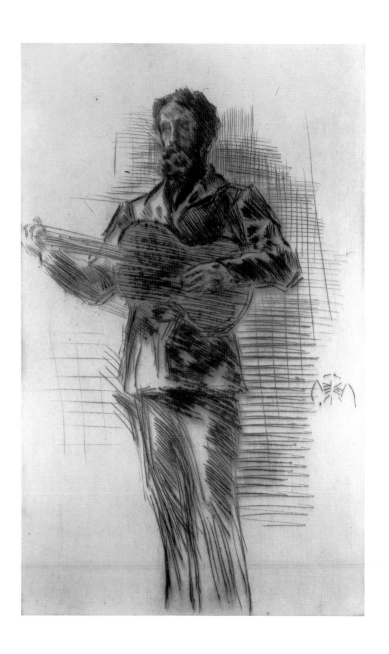

James Abbott McNeill Whistler

1834–1903

38.

The Guitar Player, 1875
Drypoint, 10⅞ x 7
Signed (in the plate, at lower right):
[Butterfly signature]

RECORDED: Edward G. Kennedy, *The
Etched Work of Whistler* (1910), p. 50 no.
140, second state of five

Whistler's drypoint portraits of the 1870s
are among his loveliest and rarest works.
Because so few impressions were printed,
they have usually retained the full richness
and velvety tonalities of the drypoint burr.
Most impressions of *The Guitar Player* were,
as here, additionally enhanced by Whist-
ler's selective wiping and modulated plate
tone. This portrait of his artist-friend
Matthew White Ridley was evidently a
personal favorite of Whistler's, for he
placed a premium price on it.

Winslow Homer

1836–1910

39.

Perils of the Sea, 1888
Etching, 16½ x 22
Signed (at lower right): Winslow Homer

RECORDED: Lloyd Goodrich, *The Graphic Art of Winslow Homer* (1968), p. 34 no. 98

Although Homer was familiar with the techniques of etching at least as early as 1876, it was not until 1884 that the medium began to assume any significant place in his work. Then, between 1884 and 1889, he completed eight major etchings based on his highly popular sea paintings and English watercolors. *Perils of the Sea*, related to a Tynemouth watercolor of 1881, was created at the height of Homer's powers as a printmaker. It reveals his masterful handling of the etching needle in constructing his compositions, with their gradations of light and dark passages, through a deft interweaving of complex clusters of line.

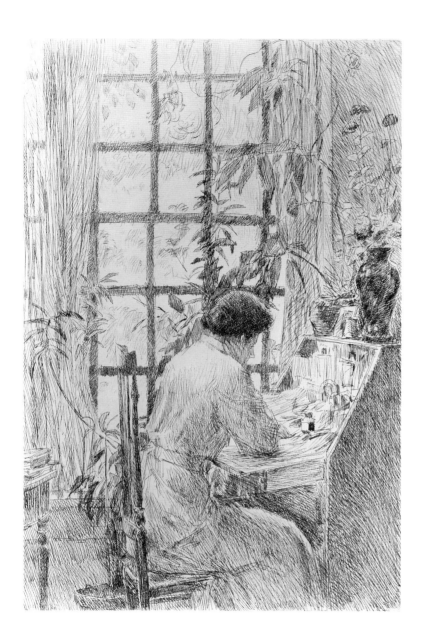

Childe Hassam

1859–1935

40.

The Writing Desk, 1915
Etching, 10 x 7
Signed (at lower right): CH imp

RECORDED: Royal Cortissoz, *Catalogue of
the Etchings and Dry-Points of Childe Hassam*
(1925), p. 23 no. 54

In 1915, at the age of fifty-six, Childe
Hassam turned to etching. Working in the
studio of artist-friend Kerr Eby at Cos Cob,
Connecticut, Hassam embraced this diffi-
cult art with characteristic exuberance.
During the first year alone, he produced a
number of prints that are regarded as
masterpieces of American Impressionism.
In *The Writing Desk*, one of his most cele-
brated etchings, Hassam has captured the
ephemeral qualities of interior light and
shade, creating a visual poem of fleeting
mood and atmosphere.

Charles Sheeler

1883–1965

41.

Roses, 1924
Lithograph, 9 ¼ x 11 ¼
Signed (at lower right): Charles Sheeler

RECORDED: Martin Gordon, "A Catalog
of the Prints of Charles Sheeler," *Photo/
Print Bulletin,* I (1976), no. 2

Roses is a rare lithographic example of
Charles Sheeler's mastery of descriptive
line and tonal harmonies. Here, as in so
many of his still lifes, Sheeler has used his
superb technical skills and perceptive eye
to endow his forms with a quiet presence
that is timeless and enduring. Although
numbered impressions indicate an edition
of thirty-five, apparently the lithograph
stone for *Roses* was accidentally damaged,
and it is thought that only a small portion
of the planned edition was ever printed.

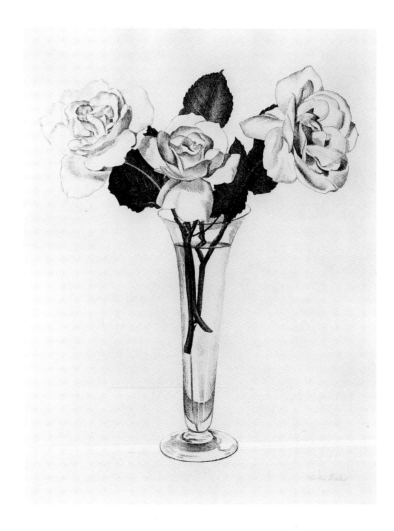

George Wesley Bellows

1882–1925

42.

Dempsey and Firpo, 1923–24
Lithograph, 18½ x 22½
Signed (at lower right): Geo Bellows

RECORDED: Lauris Mason and Joan
Ludman, *The Lithographs of George Bellows*
(1977), p. 222 no. 181

Like many of his fellow artists, Bellows
often drew on the vigorous contemporary
life of New York as subject matter for his
paintings and lithographs. His portrayals
of fight scenes, in particular, are among the
most dynamic and memorable images in
twentieth-century American art. In
Dempsey and Firpo, Bellows combines an
assured graphic sensibility with a bold
handling of the rich tonalities inherent in
lithography to create a work of great
strength and vitality.

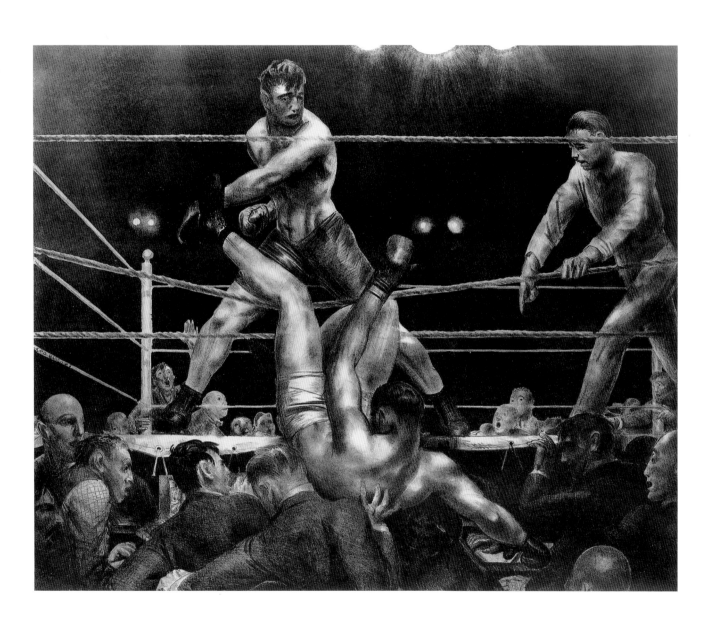

Alexander Archipenko

1877–1964

43.

Torso in Space, 1952
Serigraph, with lithography and
embossing, 15 x 23¾
Signed (at lower left): Archipenko

RECORDED: Donald Karshan, *Archipenko: The Sculpture and Graphic Art* (1974), p. 125 no. 37

Archipenko employed an unusual combination of techniques in *Torso in Space*, one of the most ambitious and successful works in his print oeuvre. Basing the serigraph on a 1935 sculpture of the same title, Archipenko achieves a similar sense of floating form by juxtaposing the lithographed, embossed figure against a nebulous, enigmatic background of luminous metallic ink and veils of color.

Stuart Davis

1892–1964

44.

Detail Study for Cliché, 1957
Color lithograph, 12 ½ x 14 ¾
Signed (at lower right): Stuart Davis;
inscribed (at lower left): 11/40

RECORDED: Sylvan Cole and Jane Myers,
*Stuart Davis: Graphic Work and Related Paint-
ings with a Catalogue Raisonné of the Prints*
(1986), p. 76 no. 24

Detail Study for Cliché was one of the last
major prints undertaken by Davis and, like
his later paintings, evinces a new clarity
and breadth of geometric form. It was
created in response to an invitation from
Margaret Lowengrund to contribute to the
Master Print series to be published by her
newly established workshop, the Pratt-
Contemporaries Graphic Art Center.
Davis' composition is based on motifs taken
from two paintings of 1955, *Cliché* and *Ready
to Wear*; its vibrant palette is related to the
latter painting.

SCULPTURE

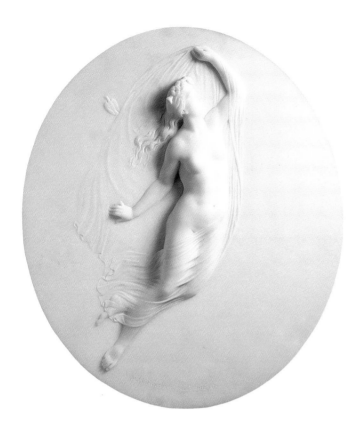
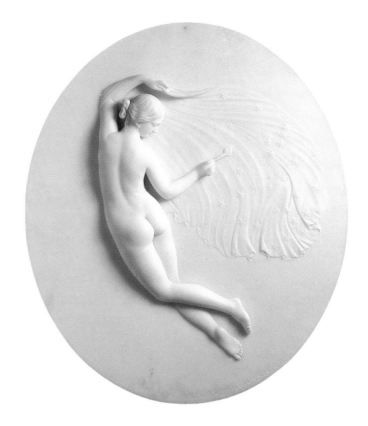

William Henry Rinehart

1825–1874

45.

Morning and *Evening*, about 1856 (models)
Marble reliefs, each 24½ x 21⅞
Each signed, dated, and inscribed (at lower center): WM.H.RINEHART.SCULPT. ROME.1874

RECORDED: cf. Marvin Chauncey Ross and Anna Wells Rutledge, *A Catalogue of the Work of William Henry Rinehart, Maryland Sculptor, 1825–1874* (1948), pp. 28–29 no. 27, pl. III // cf. William H. Gerdts, *American Neo-Classic Sculpture: The Marble Resurrection* (1973), pp. 86–87 nos. 68 and 69 illus.

EXHIBITED: Hirschl & Adler Galleries, New York, 1988, *Adventure and Inspiration: American Artists in Other Lands*, p. 50 no. 29 illus. in color // Hirschl & Adler Galleries, New York, 1989, *Uncommon Spirit: Sculpture in America 1800-1940*, p. 17 no. 7 illus. in color

This pair is one of eight sets of *Morning* and *Evening*, along with a single version of *Morning*, that Rinehart produced between 1856 and 1874. William H. Gerdts considered them to be "among the most beautiful figures in American neoclassicism." They were inspired by reliefs of the same subject by the great Danish patriarch of Neoclassical sculpture, Bertel Thorvaldsen.

William Henry Rinehart

1825–1874

46.

Sleeping Children, 1859
Marble, 14½ x 35½ x 18⅞
Signed and inscribed (on the base):
W.H.RINEHART.SCULPT

RECORDED: cf. Marvin Chauncey Ross
and Anna Wells Rutledge, *A Catalogue of
the Work of William Henry Rinehart, Mary-
land Sculptor, 1825–1874* (1948), pp. 33–35
no. 34, pl. VIII // cf. Kathryn Greenthal,
Paula Kozol, and Jan Seidler Ramirez,
*American Figurative Sculpture in the Museum
of Fine Arts, Boston* (1986), pp. 150–52
no. 50 illus.

EXHIBITED: Hirschl & Adler Galleries,
New York, 1988, *Adventure and Inspiration:
American Artists in Other Lands*, p. 51 no. 30
illus. in color // Hirschl & Adler Galleries,
New York, 1989, *Uncommon Spirit: Sculpture
in America 1800–1940*, pp. 18–19 no. 8
illus. in color

EX COLL.: private collection, Shropshire,
England, about 1925–until 1987

Sleeping Children was Rinehart's most
sought-after work, due in part to the pop-
ularity of its theme, which was also
explored by other Neoclassical marble
sculptors of the period. Nineteen marbles
are recorded as having been carved of
Rinehart's work, examples of which may
now be found in the Yale University Art
Gallery, New Haven; the Museum of Fine
Arts, Boston; the Munson-Williams-
Proctor Art Institute, Utica, New York;
the National Museum of American Art,
Washington, D.C.; and the Wadsworth
Atheneum, Hartford, Connecticut.

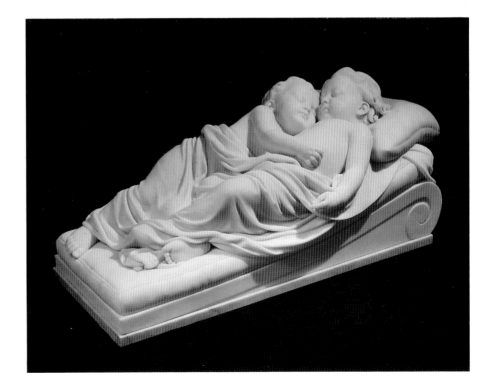

Augustus Saint-Gaudens
1848–1907

47.

Amor Caritas, 1898
Bronze with dark green patina, 39⅞ x 18
(excluding frame)
Signed and dated (at lower left):
.AVGVSTVS./SAINT GAVDENS/MDCCCXCVIII
Inscribed (at lower center): IN MEMORY
OF/NANCY.LEGGE.WOOD.HOOPER/
MDCCCXIX–MDDCCCXCVIII
Inscribed on tablet (at upper center):
.AMOR.CARITAS.

RECORDED: cf. John H. Dryfhout, *The Work of Augustus Saint-Gaudens* (1982), pp. 234–35 no. 169 illus.

EXHIBITED: Hirschl & Adler Galleries, New York, 1989, *Uncommon Spirit: Sculpture in America 1800–1940*, pp. 30–31 no. 16 illus. in color // Richard York Gallery, New York, 1989, *The Italian Presence in American Art, 1860–1920*, pp. 24, 27 no. 33 illus. in color, 44 no. 33

EX COLL.: By gift in memory of Nancy Legge Wood Hooper to the Unitarian Society, Fall River, Massachusetts, shortly after 1898–until 1986

The motif of a standing, classically draped female figure was to preoccupy Saint-Gaudens throughout his career, but none of his figures is more beautifully realized than this *Amor Caritas*. As in a number of other works, including the *Diana* for the top of Madison Square Garden, New York (now in the Philadelphia Museum of Art), Davida Johnson Clark, Saint-Gaudens' mistress and favorite model, posed for *Amor Caritas*. The sculptor produced approximately twenty bronzes of the subject in this scale, more than half of which are now in American museums.

The mahogany tabernacle frame on this work is a recent replica of the original frame on the version in The Art Institute of Chicago.

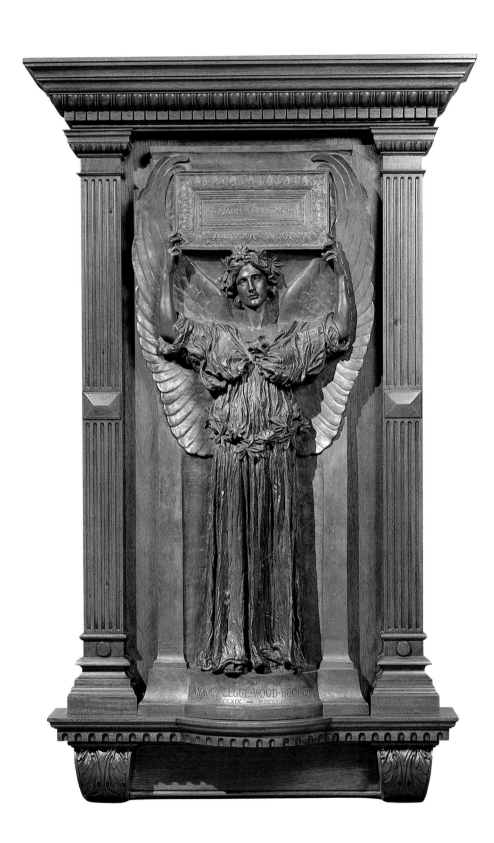

Herbert Haseltine

1877–1962

48.

Riding Off, 1906
Bronze with dark brown patina,
18¼ x 19⅜ x 10¼ (excluding marble base)
Signed, dated, and numbered (on the base):
Herbert Haseltine/No. 4 1906
Founder's mark (on the base): Valsuani/
Fondeur

RECORDED: cf. Messrs. Thos. Agnew &
Sons' Galleries, London, *Exhibition of
Equestrian Portraits in Bronze* (1921), no. 7
illus. // cf. National Sculpture Society,
New York, *Herbert Haseltine* (1948), pp. 5,
11 illus.

EX COLL.: by descent in the sculptor's
family, until 1990

Riding Off was one of Haseltine's earliest
sculptures and the first of his important
series depicting polo subjects, which also
included *Polo* (1907) and *The Meadowbrook
Team* (1909). Although trained initially as
a painter, Haseltine was encouraged to try
the art of sculpture by his teacher, the
French painter Aimé Morot. It was Morot
who suggested that Haseltine enter *Riding
Off* in the 1906 Paris Salon, where not only
was it accepted for exhibition, but it also
received an Honorable Mention. This crit-
ical recognition brought many commissions
to the young artist and firmly established
him as a sculptor rather than painter.

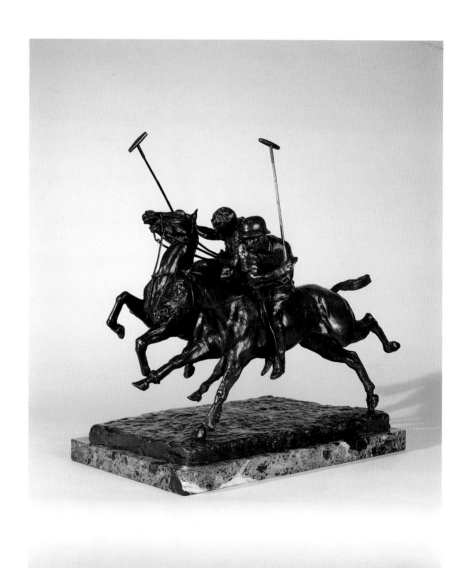

Elie Nadelman

1882–1946

49.

Standing Buck, about 1915
Bronze with dark brown patina, 27 ⅛ high
(excluding original onyx base)
Signed (on proper left antler):
ENADEMAN [*sic*]
Numbered (on proper right antler): N–2

RECORDED: cf. Lincoln Kirstein, *Elie
Nadelman* (1973), p. 305 no. 187 // cf. Whit-
ney Museum of American Art, New York,
The Sculpture and Drawings of Elie Nadelman
(1975), pp. 54 no. 46 illus., 55 no. 46, as
Buck Deer

EXHIBITED: Hirschl & Adler Galleries,
New York, 1989, *Uncommon Spirit: Sculpture
in America 1800–1940*, p. 64 no. 42 illus.
in color

Standing Buck is one of a small series of
elegant animal subjects that Nadelman
created during the early to mid-teens when
he was living first in Paris and then in
New York. These works—comprising two
freestanding horses and four deer in various
attitudes—are among the sculptor's most
graceful and elegant images, where surface
detail is minimized in favor of overall
design and fluidity of line.

Five bronzes of *Standing Buck* are cur-
rently known; the other four are in the
Museum of Art, Rhode Island School of
Design, Providence; The Fine Arts
Museums of San Francisco (Hélène Irwin
Fagan Collection); and two private collec-
tions, New York.

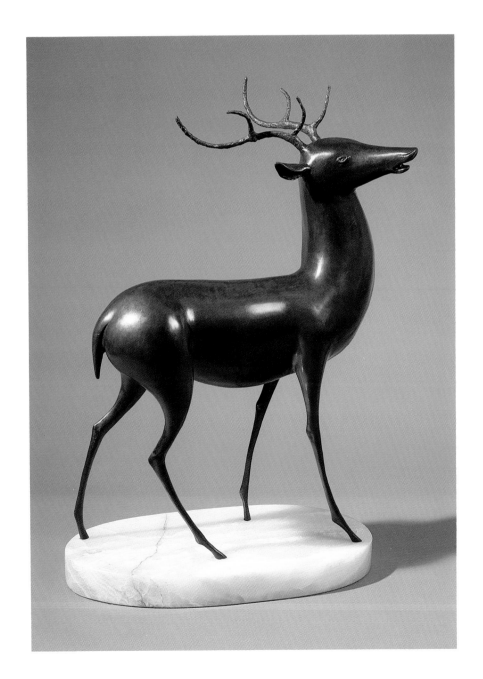

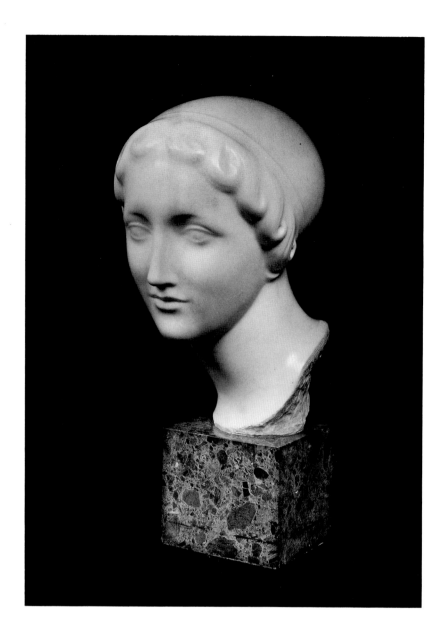

Elie Nadelman

1882–1946

50.

Idealized Female Head, about 1910–15
Marble, 15 ⅝ high (excluding marble base)
Signed (on the neck): ELIE NADELMAN

EX COLL.: the sculptor; by gift to private
collection; by descent in the family, until
1990

This idealized marble head is part of a
group of related heads that Nadelman
created from about 1906 on, while living in
Paris and, later, New York. They were
inspired by the Hellenistic fragments that
Nadelman would have seen at the Louvre,
although they are not mere copies of
antique models. With their highly polished
surfaces, decorative, wavy patterns of hair,
and abstracted facial expressions, these
works could have been created only by
Nadelman, whose distinctive style emerged
during his years in Paris.

Paul Manship

1885–1966

51.

Flight of Night, 1916
Bronze with dark brown patina, 26½ high
(excluding original stepped marble base),
36 high (overall)
Signed, dated, and inscribed (on the ball):
PAUL MANSHIP © 1916
Founder's mark (on the ball): ROMAN
BRONZE WORKS N-Y-

RECORDED: cf. Albert E. Gallatin, *Paul
Manship: A Critical Essay on His Sculpture and
an Iconography* (1917), pp. 5, 15, n.p. illus. //
cf. Edwin Murtha, *Paul Manship* (1957),
pp. 14, 153 fig. 2, 158 no. 81, incorrectly
sized at 37 in. high, excluding marble base
// cf. Minnesota Museum of Art, Saint
Paul, *Paul Manship: Changing Taste in Amer-
ica* (1985), p. 71 no. 44 illus., illus. in color
on front cover

EXHIBITED: Hirschl & Adler Galleries,
New York, 1986, *Modern Times: Aspects of
American Art, 1907–1956*, pp. 72–73 no. 65
illus. in color // Hirschl & Adler Galleries,
New York, 1989, *Uncommon Spirit: Sculpture
in America 1800–1940*, pp. 78–79 no. 53
illus. in color

EX COLL.: Mrs. Rodney Chase, Water-
town, Connecticut, about 1925–until 1986
(probably acquired from Milch Gallery,
New York)

With its composition of a figure moving
through space, emphasis on silhouette and
purity of outline, and careful attention to
decorative detail, *Flight of Night* shows the
influence of Indian art, particularly Hindu
and Buddhist sculpture. According to
Edwin Murtha (*op. cit.*, p. 158), the work
was produced in an edition of six bronzes in
this large size, other examples of which are
in The Corcoran Gallery of Art, Washing-
ton, D.C.; the Toledo Museum of Art,
Ohio; and the Minnesota Museum of Art,
Saint Paul. The image was also made in
reduction (14⅜ in. high, excluding marble
base) in an edition of twenty.

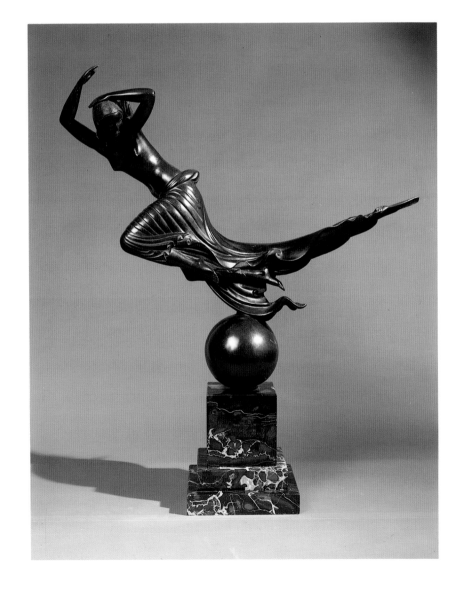

Gaston Lachaise

1882–1935

52.

Man Walking (Portrait of Lincoln Kirstein), 1932–33
Bronze, parcel-gilt, 20⅞ high (excluding original black marble base)

RECORDED: cf. Gerald Nordland, *Gaston Lachaise: The Man and His Work* (1974), pp. 102, 104 fig. 44, 106 // cf. Whitney Museum of American Art, New York, *Gaston Lachaise: A Concentration of Works from the Permanent Collection of the Whitney Museum of American Art* (1980), pp. 25, 26 illus., 27 // cf. National Portrait Gallery, Washington, D.C., *Gaston Lachaise: Portrait Sculpture* (1985), pp. 142, 143 illus. // Lincoln Kirstein, *Quarry: A Collection in Lieu of Memoirs* (1986), pp. 26, 27 illus.

EXHIBITED: The Museum of Modern Art, New York, 1935, *Gaston Lachaise: Retrospective Exhibition*, p. 27 no. 51, illus., as *Portrait Figure* // M. Knoedler & Company, New York, 1947, *Gaston Lachaise 1882–1947*, p. 18 no. 25, as *Portrait Figure*

EX COLL.: the sculptor; to Lincoln Kirstein, New York, 1933; by gift to the School of American Ballet, New York, until 1989

In creating this standing nude portrait of Lincoln Kirstein, collector, connoisseur, and founder of the School of American Ballet, Lachaise was inspired by a small gold and enamel Egyptian figure of a pharoah as the god Amun in The Metropolitan Museum of Art. The artist rendered the freestanding figure in an animated, expressive posture that suggests balletic sources as well as modernism. The present bronze was cast in Germany with flecks of gold alloy, giving it a rich and variegated surface color. It is one of two bronzes of the subject, the other of which is in the Whitney Museum of American Art, New York.

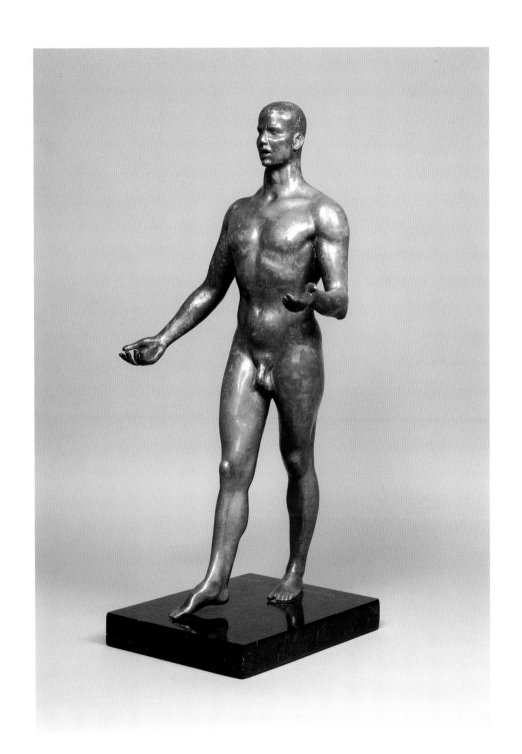

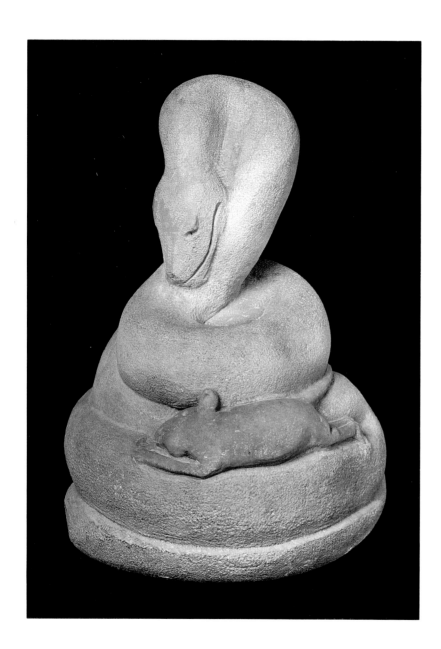

John Bernard Flannagan

1895–1942

53.

Snake, 1938
Limestone, 25⅜ high

RECORDED: letter, Robert S. Ingersoll to
Stuart P. Feld, Hirschl & Adler Galleries,
New York, Sept. 1, 1987 (Hirschl & Adler
archives) // Dick Siersema, *Rhyme and Reason*
(1988), p. 174 illus., as *Cobra and Mongoose*

EXHIBITED: The Museum of Modern Art,
New York, 1942, *The Sculpture of John B.
Flannagan*, pp. 33 illus., 39 no. 33 // Whit-
ney Museum of American Art, New York,
1976, *200 Years of American Sculpture*, pp.
143, 144 no. 209 illus., 339 no. 68, as *Cobra
and Mongoose*, granite // Nassau County
Museum of Fine Art, Roslyn, New York,
1981–82, *Animals in American Art*, no. 75
illus., as *Cobra and Mongoose* // Hirschl &
Adler Galleries, New York, 1986, *From the
Studio: Selections of American Sculpture 1811–
1941*, pp. 72–73 no. 47 illus. in color //
Hirschl & Adler Galleries, New York, 1986,
*Modern Times: Aspects of American Art, 1907–
1956*, pp. 46–47 no. 38 illus. in color //
Hirschl & Adler Galleries, New York, 1989,
*Uncommon Spirit: Sculpture in America 1800–
1940*, p. 93 no. 65 illus. in color

EX COLL.: R. Sturgis Ingersoll, Philadel-
phia, by 1942; to his estate; to [Sotheby
Parke Bernet, New York, March 21, 1974,
sale 3617, *Twentieth Century American Paint-
ings, Drawings and Sculpture*, no. 134 illus.];
to [Graham Gallery and Zabriskie Gallery,
New York]

Carved in 1938, *Snake* is one of Flannagan's
largest and most compelling works. It was
inspired by a visit to the Philadelphia Zoo
that the sculptor made with his friend and
patron, R. Sturgis Ingersoll. Flannagan's
work is often endowed with universal and
timeless themes; in this case, the struggle
between life and death is expressed in a
confrontation between predator and prey.

John Storrs

1885–1956

54.

Modern Madonna, about 1918
Polychromed terra-cotta, 23 high
Signed (on the base, at back): STORRS

RECORDED: cf. Michael Edward Shapiro,
"Twentieth Century American Sculpture,"
The Bulletin of The Saint Louis Art Museum,
XVIII (Winter 1986), p. 15 illus. // cf.
Whitney Museum of American Art, New
York, *John Storrs* (1986, text by Noel
Frackman), p. 21 fig. 8

EXHIBITED: Hirschl & Adler Galleries,
New York, 1989, *Uncommon Spirit: Sculpture
in America 1800–1940*, p. 87 no. 60 illus. in
color

EX COLL.: the sculptor; by gift to a pri-
vate collection, until 1990

As in this work, Storrs frequently applied
areas of color to his terra-cottas and plasters,
or combined differently colored metals in
his bronzes, to enhance their cubistic
qualities. This *Modern Madonna*, known
only in terra-cotta, was made in two sizes,
the present work being the larger of the
two. Another example in this scale, which
does not display the same vivid poly-
chromy, is in The Saint Louis Art Museum.
Reduced versions (11⅛ in. high) are known
in two private collections.

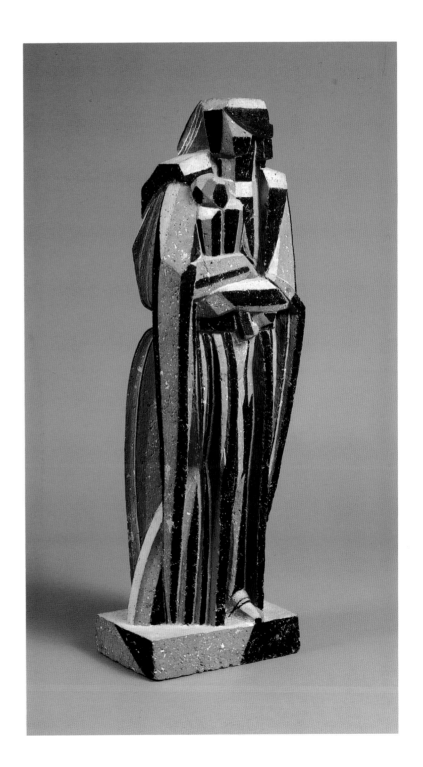

EIGHTEENTH & NINETEENTH-CENTURY DECORATIVE ARTS

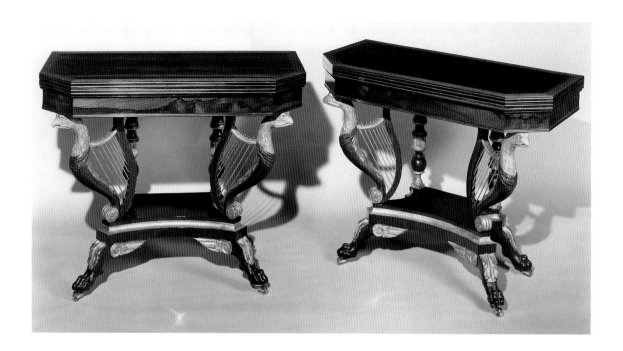

Attributed to Duncan Phyfe

1766–1854

55.

Pair of Card Tables with Griffin and Harp Supports, New York, about 1815–20
Rosewood, secondary woods painted verde antique and gilded, striped maple, plaster rosettes gilded, and brass die-stamped and line inlay and castors, each 29¼ x 36¼ x 18 (36¼ deep with top open)

RECORDED: Samuel Chamberlain and Narcissa Chamberlain, *Southern Interiors of Charleston South Carolina* (1936), p. 51 illus. one of this pair

EX COLL.: William Mason Smith, Charleston, South Carolina; by descent in his family to Mrs. William Mason Smith, Charleston and New York, until 1988

This pair of card tables and accompanying sofa table are unique. With gilded and painted verde antique griffin and harp supports, they are part of a substantial group of figural furniture of New York origin dating from about 1815–20. Although often generically attributed to the French émigré cabinetmaker Charles-Honoré Lannuier, the furniture in this group is more robust and creative in its combination of elements than the purely French Empire style of Lannuier and is very likely the work of Lannuier's principal New York competitor, Duncan Phyfe.

An attribution to Phyfe is further confirmed by a comparison of the rear columnar supports on the card tables to the corresponding supports on a much simpler card table made by Phyfe for James Lefferts Brinckerhoff and documented by a bill of sale dated October 26, 1816, itemizing work done between that date and September 29, 1815 (see Jeanne Vibert Sloane, "A Duncan Phyfe Bill and the Furniture It Documents," *The Magazine Antiques,* CXXXI [May 1987], pp. 1106–11, fig. 6).

Attributed to Duncan Phyfe

1766–1854

56.

Sofa Table with Griffin and Harp Supports,
New York, about 1815–20
Rosewood, secondary woods painted verde
antique and gilded, striped maple, plaster
rosettes gilded, and brass die-stamped and
line inlay and castors, 28 ½ x 40 ½ x 27 ½
(57 ¼ wide with two leaves extended)

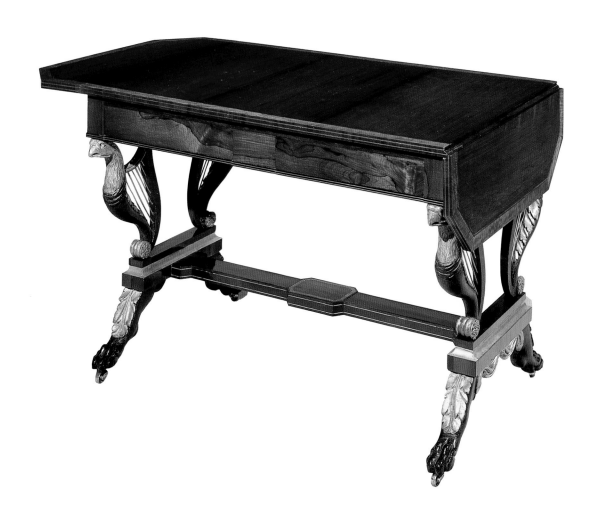

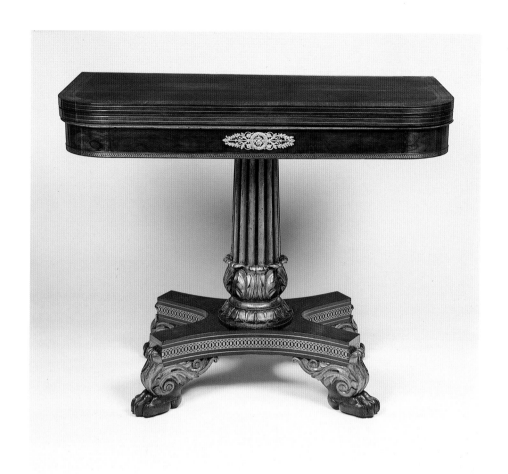

Attributed to Duncan Phyfe

1766–1854

57.

Neoclassical Card Table with Columnar Support, New York, about 1820
Rosewood, partially painted verde antique and gilded, with brass castors and die-stamped and line inlay, and ormolu mount, 29⅜ x 36 x 18 (36 deep with top open)

Essentially a New York interpretation of the French Restauration style, this table also shows the influence of the Regency period in England. It represents the ultimate level of craftsmanship and design of the Classical Revival period in the United States.

A pair of tables of similar form and design, more purely in the aesthetic of the French Restauration, is in The Metropolitan Museum of Art (The Metropolitan Museum of Art, New York, *19th-Century America, Furniture and Other Decorative Arts* [1970], fig. 71).

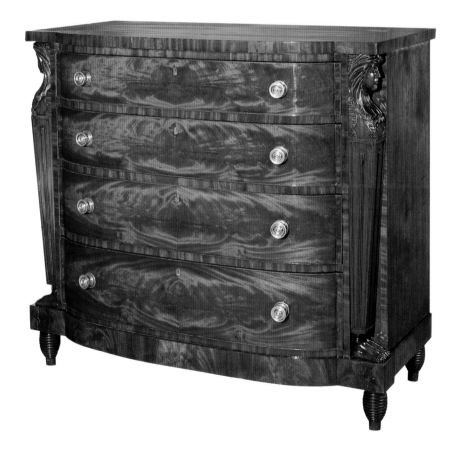

Attributed to Joseph B. Barry & Son

active 1810–1822

58.

"Eliptic Bureau" with *"Columns and Egyptian Figures,"* Philadelphia, 1815
Mahogany, with gilt brass knobs,
42 x 47¾ x 23½

RECORDED: Robert T. Trump, "Joseph B. Barry, Philadelphia Cabinetmaker," *The Magazine Antiques*, CXXXII (May 1989), p. 1216 pl. V, an example with beehive feet; p. 1217 pl. VI, another example with a plinth base

This bureau is among the most fully developed of several examples of a form that is attributed to Joseph Barry on the basis of his offer in the *Philadelphia Aurora General Advertiser* for March 30, 1815, to sell, "3 pair Eliptic Bureaus, columns and Egyptian figures."

All examples of this type of bureau have bow fronts with richly flamed mahogany veneers. They stand either on horizontally reeded legs, usually described as beehive in shape, or on a plinth base similar to those published in George Smith, *A Collection of Designs for Household Furniture and Interior Decoration* (1808). The tapered square columns with stylized human feet and busts of turbaned or unturbaned Egyptian figures were probably derived from Thomas Sheraton's *Cabinet Maker, Upholsterer and General Artist's Encyclopedia* (1793).

59.

Chippendale Side Chair with Shell Ears,
Philadelphia, about 1765
Mahogany, 40½ high

RECORDED: cf. William M. Hornor, Jr.,
Blue Book, Philadelphia Furniture, 1682–1807
(1935), pp. 73–74 figs. 220, 221 // cf. Edwin
J. Hipkiss, *Eighteenth-Century American Arts:
The M. and M. Karolik Collection* (1941),
p. 146 fig. 84 // cf. Joseph K. Kindig, *The
Philadelphia Chair 1685–1785* (1978), fig. 40
// cf. Christopher P. Monkhouse and
Thomas S. Michie, *American Furniture in
Pendleton House* (1986), pp. 168–69 figs. 110,
111

EX COLL.: Philadelphia cabinetmaker
Henry Connelly; by descent to Gladys
Connelly; private collection, about 1950–89

One of the most highly developed designs
produced in Philadelphia during the Chip-
pendale period, this mahogany side chair
recalls its Rococo origins with an elabo-
rately carved shell and leafage motif. Other
characteristics that rank it among the very
best Philadelphia furniture of the period
include the carefully carved shell ears,
elaborately modeled shells on the crest and
seat rails, a carved ribbon splat, delicately
fluted stiles, and perfectly proportioned
cabriole legs terminating in boldly carved
ball and claw feet. Closely related variants
are in the Museum of Fine Arts, Boston,
and in Pendleton House at the Museum of
Art, Rhode Island School of Design,
Providence, both of which have tradition-
ally been attributed to the distinguished
Philadelphia cabinetmaker Thomas Affleck.

Although possibly revarnished a century
ago, this chair still retains its original
surface.

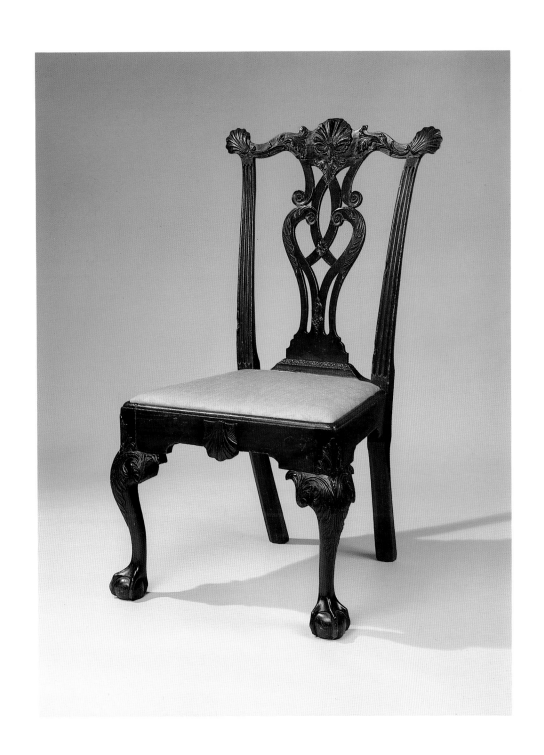

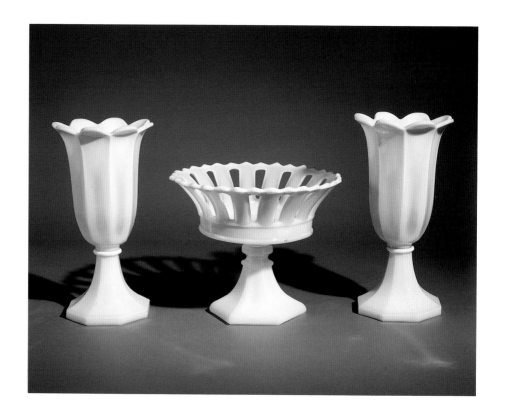

Attributed to Boston and Sandwich Glass Company, Sandwich, Massachusetts

60.

Fiery Opalescent Openwork Compote,
about 1835–45
Glass, pressed, 7⅜ x 9 diameter

RECORDED: cf. Ruth Webb Lee, *Sandwich Glass* (1947), pp. 397 pl. 153, 398

EX COLL.: William J. Elsholz, Detroit, until 1987

Pair of Fiery Opalescent Octagonal Footed Tulip Vases, about 1835–45
Glass, pressed, each 10⅛ high

RECORDED: cf. Ruth Webb Lee, *Sandwich Glass* (1947), pp. 481, 483 pl. 198 no. 2 // cf. George S. and Helen McKearin, *American Glass* (1948), pp. 388 pl. 201 no. 40, 391 no. 40 // cf. Jane Shadel Spillman, *American and European Pressed Glass in The Corning Museum of Glass* (1981), p. 219

EX COLL.: William J. Elsholz, Detroit, until 1986

The difficulty in pressing glass in the complex mold in which the compote was formed must, to a considerable extent, account for its extraordinary rarity. Although compotes and vases of these designs were produced in an array of colors, very few examples have been found in fiery opalescent.

New England Glass Company,
Cambridge, Massachusetts

61a.

*Clear Blown Pitcher with Applied Handle
and Threading*, about 1830
Glass, blown, with silver coin, 7⁹⁄₁₆ high

RECORDED: Carl U. Fauster, ed., *Libbey
Glass 1818–1888* (1979), p. 187

EX COLL.: William J. Elsholz, Detroit,
until 1986

Attributed to Thomas Cains, Phoenix
Glass Works, South Boston,
Massachusetts, *or* New England Glass
Company, Cambridge, Massachusetts

61b.

Monumental One-Handled Urn,
second quarter of the nineteenth century
Glass, blown, with 1834 silver dime in the
stem, 8⅝ high

Attributed to Boston and Sandwich
Glass Company, Sandwich,
Massachusetts

61c.

*Clear Blown Three-Mold Covered Sugar
Bowl,* about 1825–35
Glass, blown-molded and free-blown, 6 high

EX COLL.: William J. Elsholz, Detroit,
1974–86

Attributed to Boston and Sandwich
Glass Company, Sandwich,
Massachusetts, *or* New England Glass
Company, Cambridge, Massachusetts

61d.

Bank, second quarter of the nineteenth
century
Glass, blown, 5¾ high

These four pieces of blown glass were all
produced in the eastern Massachusetts
area during the second quarter of the nine-
teenth century. Fabricated with various
techniques of blowing and pressing, often
in combination, they are representative of
the imaginative approach of the glass
blower, perhaps at his most innovative in
the "off-hand" pieces made for family and
friends at the end of a work day.

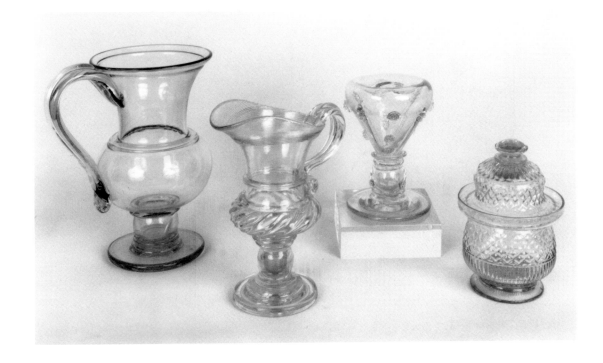

62.

Sideboard, Boston or Salem, 1829
Mahogany, 40½ x 85¼ x 29½ (49 high to
top of backsplash)
Dated (inside top left drawer): April 1829

Cellarette, Boston or Salem, 1829
Mahogany, with lead liner with ormolu
decoration, 25¾ x 29 x 18

This magnificent sideboard and matching
cellarette made for the Salem financier and
philanthropist George Augustus Peabody
(1775–1869), 29 Washington Square,
Salem, are among the finest examples of
Boston area cabinetmaking of the later Neo-
classical period. Displaying the strong
influences of the English Regency style and
specifically the designs published in London
by George Smith, Thomas Hope, and
T. King during the first quarter of the
nineteenth century, these pieces incorpo-
rate anthemion carved design elements
similar to those displayed on a chamber
organ made by George G. Hook (1805–
1881) of Salem in 1827. They relate as well
to a console table and looking glass also
originally belonging to George Peabody
(see *The Magazine Antiques*, CXI [May
1977], pl. XVI), all in a style that is
extremely close to work being produced in
Boston by such firms as Emmons and
Archibald and Isaac Vose and Son. In part
because the works in the organ were by a
Salem maker, it has also been suggested
that these high-style Peabody pieces could
also be of Salem origin.

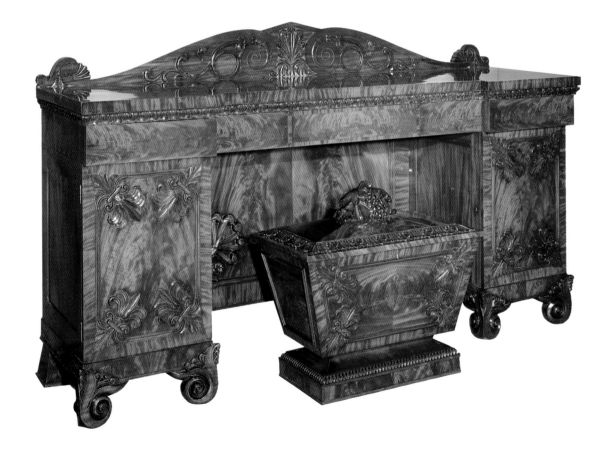

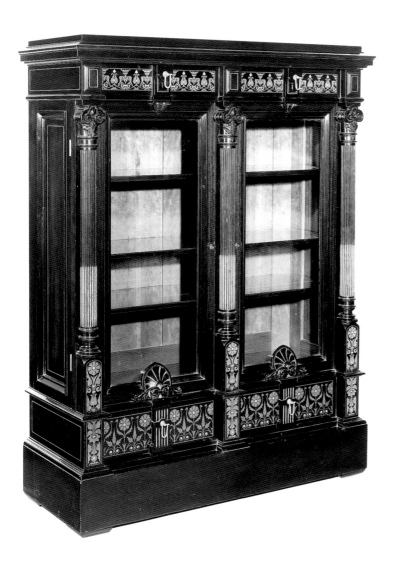

Attributed to Herter Brothers

Active 1865–1905

63.

Book Case in the Aesthetic Taste,
New York, about 1875–80
Cherry wood, ebonized, and maple, with
satinwood inlay, brass drop pulls, glazed
doors, and silk velvet, 61 x 48 x 17½
Courtesy of Margot Johnson Gallery,
New York

Although this piece retains some elements
of the Renaissance Revival vocabulary,
such as fluted columns with superbly
carved capitals and anthemion decoration
beneath the glazed doors, it is nevertheless
an example of the Aesthetic Movement,
which was a reaction to the excesses of the
earlier style. The use of ebonized cherry
wood and the enhancement of the lower
drawers with inlay of unusually large styl-
ized sunflowers are characteristic of the
Aesthetic Movement in the United States.

THE ARTS & CRAFTS MOVEMENT

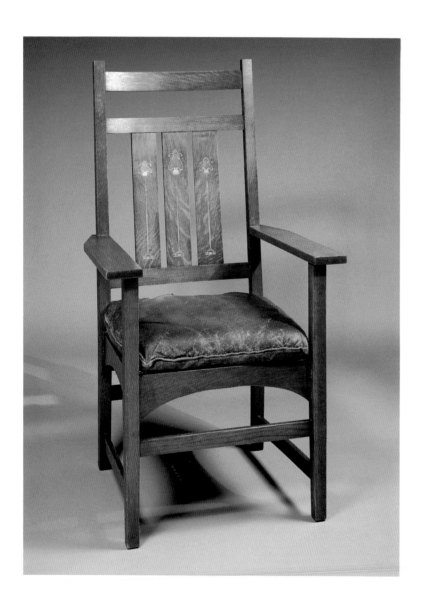

Gustav Stickley

1858–1942

Harvey Ellis, *designer*

1852–1904

64.

Inlaid Arm Chair, about 1903–04
Oak, with copper, pewter, and fruitwood
inlay, 43 high
Signed with red decal (underneath the
right arm): Als/ik/Kan/Stickley

RECORDED: David M. Cathers,
Stickley Craftsman Furniture Catalogues (1979),
p. v illus. a similar example // David M.
Cathers, *Furniture of the American Arts and
Crafts Movement* (1981), p. 147, p. 128 illus.
a similar example // Stephen Gray and
Robert Edwards, eds., *Collected Works of
Gustav Stickley* (1981), p. 52 illus. a similar
example

EX COLL.: private collection, Wisconsin

Gustav Stickley

1858–1942

Harvey Ellis, *designer*

1852–1904

65.

Inlaid Fall Front Desk, about 1903–04
Oak, with copper, pewter, and wood inlay,
44 x 30¼ x 12⅞
Signed with red decal (on the center of the
upper back panel): Als/ik/Kan/Stickley

RECORDED: cf. Stephen Gray and Robert
Edwards, eds., *Collected Works of Gustav
Stickley* (1981), p. 48

EXHIBITED: Hirschl & Adler Galleries,
New York, 1989, *From Architecture to
Object: Masterworks of the American Arts &
Crafts Movement*, p. 40 no. 11 illus. in color

EX COLL.: probably purchased at the
Louisiana Purchase Exposition in St. Louis,
1904; to private collection; by descent in
the family, until 1988

Harvey Ellis, a nomadic architect and bril-
liant draftsman who suffered from chronic
alcoholism, was hired by Stickley in 1903.
In the remaining nine months of his life, he
designed houses, furniture, and wall deco-
rations for Stickley's United Crafts Work-
shop. His furniture designs, characterized
by curved aprons, thin, overhanging tops,
and, in general, a light, sophisticated look,
were influenced by the work of the British
Arts & Crafts Movement and balanced the
more massive and stocky proportions of
Stickley's designs.

The death of Ellis and the high cost of
production led to the discontinuation of
the line after June 1904. The short pro-
duction life of the pieces and their status as
the last of Ellis' designs makes them highly
prized and extremely rare. This desk is one
of Harvey Ellis' finest and most compact
designs for Stickley.

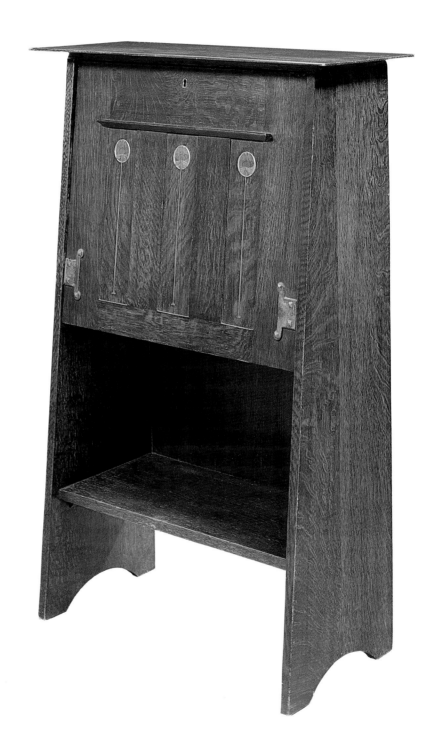

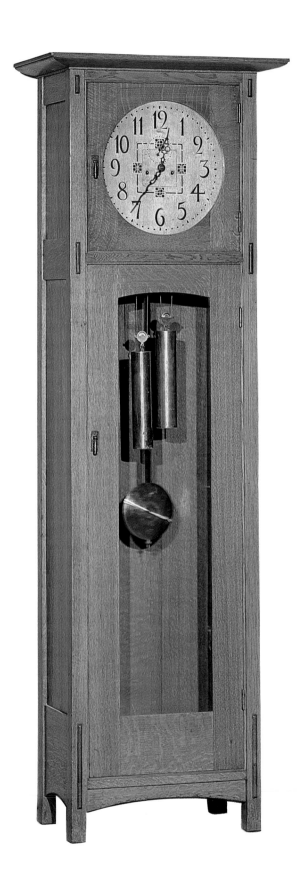

Leopold Stickley

1869–1957

John George Stickley

1871–1921

66.

Tall Case Clock, about 1908
Oak, with iron hinges, 80¼ x 27 x 16¾
Signed (on clock face): L. & J.G. STICKLEY
FAYETTEVILLE/HANDCRAFT; (on the
back): [red Handcraft decal]

RECORDED: Stephen Gray, ed., *The Mission Furniture of L. & J.G. Stickley* (reprint 1983), p. 135 no. 86, illus. an identical example // Kathleen Quigley, "A Stickley Grandson Keeps Family Heritage Alive," *The New York Times*, May 12, 1983, p. C6

EXHIBITED: The Everson Museum of Art, Syracuse, New York, 1985, *Syracuse Collects Arts & Crafts & Made in Syracuse Today: Contemporary Work in Wood*, as *Clock*, dated about 1912 // Hirschl & Adler Galleries, New York, 1989, *From Architecture to Object: Masterworks of the American Arts & Crafts Movement*, p. 54 no. 25 illus. in color

EX COLL.: Gustav Stickley; by gift to Mrs. Robert Bonner; to Peter Wiles, Sr., the artist's grandson, until 1988

According to family tradition, this clock was made by Leopold Stickley for his brother Gustav. Gustav gave the clock as a gift to Mrs. Bonner, who later returned it to the Stickley family. It remained in the family's main residence at 438 Columbus Avenue, Syracuse, until 1988. Although L. & J.G. Stickley designed another version of the tall case clock, the large size, elegant proportions, and fine detailing of this particular clock, which retains its original fittings, pendulums, and internal works, make it the best of its kind.

Dirk Van Erp

1859–1933

67.

Table Lamp, about 1915–27
Copper, with mica shade, 17½ x 18½
diameter
Impressed mark (on the bottom): DIRK
VAN ERP [within broken box with right
corner missing, below windmill]/SAN
FRANCISCO

EXHIBITED: Hirschl & Adler Galleries,
New York, 1989, *From Architecture to Object:
Masterworks of the American Arts & Crafts
Movement*, p. 125 no. 85 illus. in color

EX COLL.: Marion Elizabeth Brown and
Jean Williamson, Berkeley, California, until
1984–85; private collection, San Francisco

The red warty finish usually found in Van
Erp vases occurs very rarely in lamps.
Noted for its rich and irregular surface, the
finish derives from the forging process,
when the heating, soldering, and hammer-
ing of the object into its final shape changes
the color of the copper sheet to the reddish
tones seen here. Although Van Erp liked
this more rustic look, he infrequently left
objects in this state. Occasionally, however,
he saw the rough hammering and red color
as particularly appropriate to a piece, and it
was left in this form, rather than being
given a final hammering and finishing.

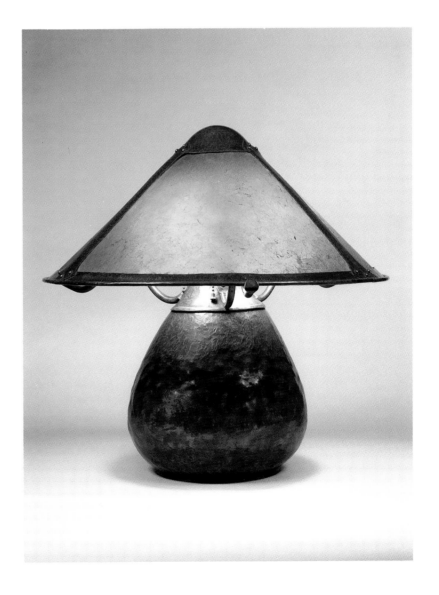

Charles Sumner Greene

1868–1957

Henry Mather Greene

1870–1954

68.

Pair of Living Room Armchairs from the Charles M. Pratt House, Ojai, California, about 1909
Mahogany and ebony, with inlaid fruit-wood and original leather upholstery, each 35 ¼ high
Marked with brand (inside rail behind cushion): Sumner Greene/His True Mark

RECORDED: Randell L. Makinson, *Greene & Greene: Furniture and Related Designs* (1979), pp. 95 illus. in situ, 97 illus.

EXHIBITED: Hirschl & Adler Galleries, New York, 1989, *From Architecture to Object: Masterworks of the American Arts & Crafts Movement* (not in cat.)

Along with the Blacker, Ford, and Gamble houses in Pasadena and the Thorsen house in Berkeley, the Charles M. Pratt house, in Ojai Valley, was considered one of Greene and Greene's ultimate bungalows. This pair of living room armchairs is distinguished by gently curving arms and pierced crest rails and stretchers. The subtle use of fruitwood inlay on the crest rails, which recalls a gnarled fruit-laden tree inspired by a California white oak, and the leather back rests enframed by thin strips of ebony are painterly touches that not only reflect the architects' concern for craftsmanship, but also their sensitivity to Japanese influence.

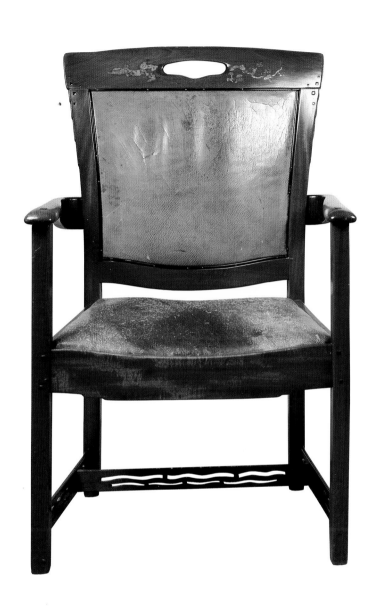
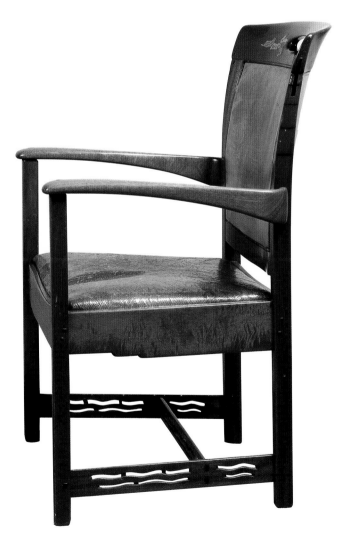

Charles Sumner Greene

1868–1957

Henry Mather Greene

1870–1954

69.

Sideboard from the Robert R. Blacker House, Pasadena, California, 1907–09
Mahogany and ebony, with copper, pewter, and mother-of-pearl inlay,
95 ¼ x 22 ¼ x 38 ⅛

RECORDED: Randell L. Makinson, *Greene & Greene: Architecture as a Fine Art* (1977), pp. 150–55, 154 illus. an identical example in situ

EXHIBITED: Hirschl & Adler Galleries, New York, 1989, *From Architecture to Object:*

Masterworks of the American Arts & Crafts Movement, p. 111 no. 74 illus. in color

Part of a complete dining ensemble, this sideboard exemplifies the meticulous workmanship and unique design characteristic of the Greenes' work. It incorporates mother-of-pearl inlay in an Oriental style and ebony pegs that were matched to both the woodwork of the room and its other furniture to create a totally unified effect. All of the Greenes' designs for the Blacker House furniture were executed by Peter and John Hall of the Peter Hall Manufacturing Company, who worked with the Greenes from 1905 into the teens. The Halls were extraordinary craftsmen who were able to comply with Charles Greene's insistence on quality workmanship in the execution of his intricate designs.

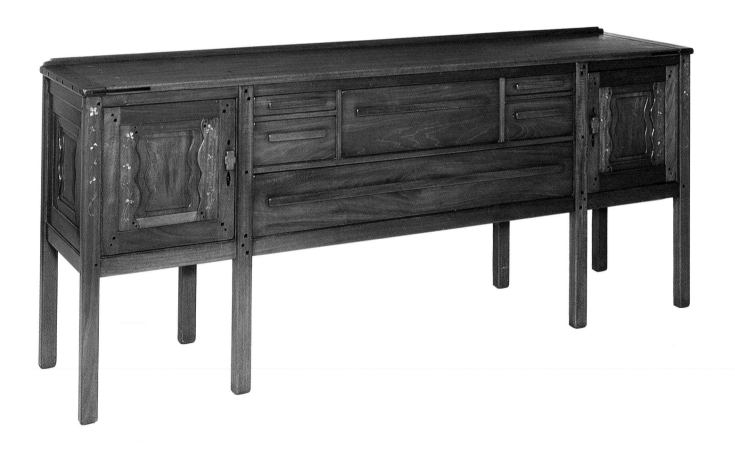

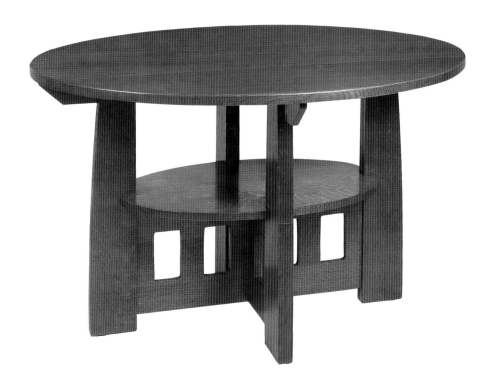

Charles P. Limbert

1854–1923

70.

Oval Center Table, about 1906
Oak, 30 x 36 x 48

RECORDED: *Limbert's Holland Dutch
Arts and Crafts Furniture* (reprint 1981),
p. 50 no. 158 illus. an identical example

Like many furniture designers in Grand
Rapids, then a major center for furniture
manufacturing, Limbert was aware of, and
receptive to, international currents, partic-
ularly the work of Josef Hoffmann in
Austria and Charles Rennie Mackintosh
in Scotland. Limbert's center table, while
recalling Mackintosh's designs for the
Willow Tea Rooms of 1903, is more grace-
ful and dynamic through its incorporation
of gently swelling legs and lower oval shelf
supported by broad stretchers pierced by
rectangular cutouts. The total effect is one
of solidity and grace, which characterize
Limbert's best designs between 1904 and
1906.

Frank Lloyd Wright

1867–1959

71.

Dining Table with Eight Chairs from the Barton House of the Darwin Martin Complex, Buffalo, New York, about 1904
Table: oak, 28¾ high; top, 69 x 54½, with two leaves, each 15 x 54½
Chairs: oak, with upholstered seats, each 46 high

EXHIBITED: Hirschl & Adler Galleries, New York, 1989, *From Architecture to Object: Masterworks of the American Arts & Crafts Movement,* pp. 88–89 no. 56 illus. in color

The Barton House was designed for Mrs. Darwin Martin's sister and her husband and was part of a large residential complex Wright built in Buffalo for the Martin family. The chairs, with their signature tall spindled backs, and the dining table recall an earlier design by Wright for the Susan Lawrence Dana House, Springfield, Illinois, of 1902. The Darwin Martin House and outbuildings proved to be one of the most successful commissions of Wright's Prairie period.

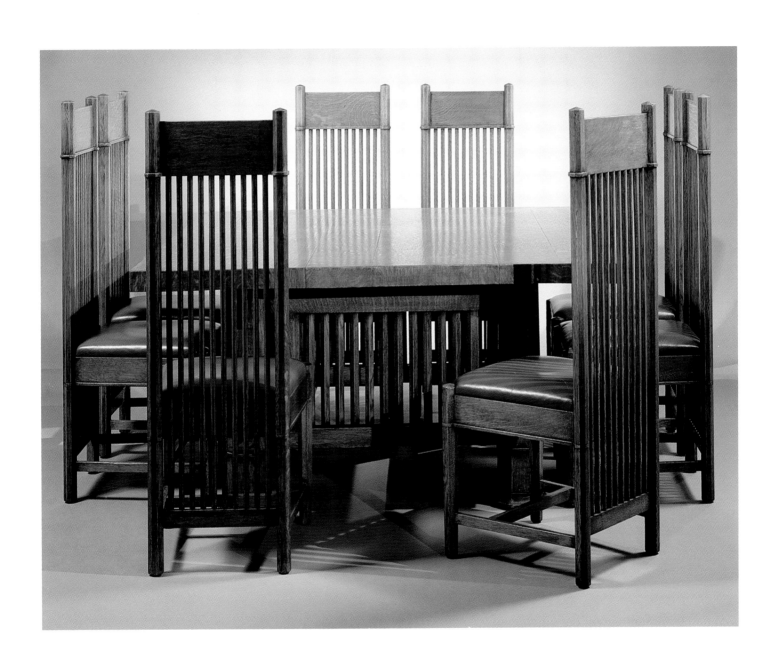

George Grant Elmslie

1871–1952

72.

Pair of Windows from the Henry B. Babson House, Riverside, Illinois, about 1924
Leaded glass, each 44½ x 16½

EXHIBITED: Hirschl & Adler Galleries, New York, 1989, *From Architecture to Object: Masterworks of the American Arts & Crafts Movement,* p. 71 no. 40 illus. in color

EX COLL.: Henry B. Babson, Riverside, Illinois, until about 1960; to Mr. Holt, Riverside, Illinois; to his wife, until 1986; to [Christie's, New York, June 13, 1986, sale 6168, nos. 88 and 89]; to [Don Magner, Brooklyn, New York]

Henry B. Babson's house in Riverside, Illinois, was designed by Louis Sullivan in 1907 and completed in 1909. George Elmslie, then employed by Sullivan, was responsible for designing the interior, including furnishings and ornamental windows. Babson retained Elmslie on two separate occasions to make revisions to the house—once in 1912–13, when a sleeping porch was enclosed and new ornamental windows installed, and again around 1924, when second stories were added to several of the wings. The present windows date from the later remodeling and were probably installed in the new upper stories. Their vivid colors and geometric shapes recall Frank Lloyd Wright's earlier designs for the Avery Coonley Playhouse, also in Riverside, of 1912.

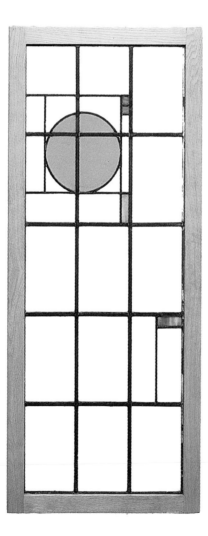

Frank Lloyd Wright

1867–1959

73.

*Spindled Barrel Chair from the Herbert F.
Johnson, Jr. House, "Wingspread," Wind
Point, Wisconsin,* about 1937
Oak, with upholstered seat, 30¼ high

RECORDED: Henry-Russell Hitchcock,
*In the Nature of Materials: The Buildings of
Frank Lloyd Wright, 1887–1941* (1942), figs.
341, 342 illus. identical examples in situ

Based on a chair Wright designed for the
Darwin D. Martin House, Buffalo, New
York, in 1904, this barrel chair was adapted
for Herbert Johnson's magnificent home,
"Wingspread," near Racine, and was later
used in a remodeling of Taliesin in Spring
Green. Johnson commissioned Wright to
design the house while he was still at work
on the Johnson Wax Building (1936–39),
now regarded as one of Wright's master-
pieces. Wright considered "Wingspread"
to be the last of his Prairie houses.

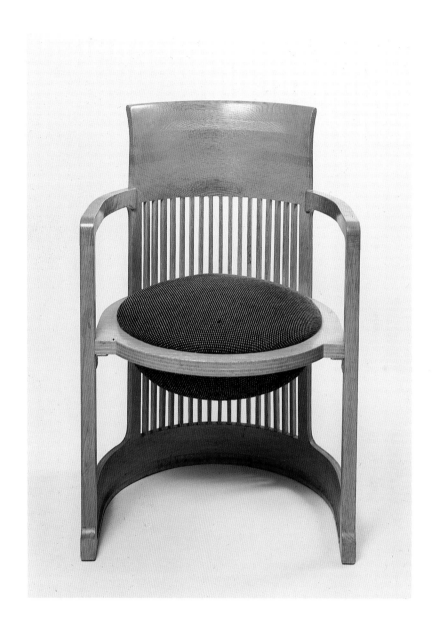